BRIGHTON & HOVE
THEN & NOW

IN COLOUR

PAUL K LYONS

WITH IMAGES FROM THE REGENCY SOCIETY

The
History
Press

First published in 2013

The History Press
The Mill, Brimscombe Port
Stroud, Gloucestershire, GL5 2QG
www.thehistorypress.co.uk

ISBN 978 0 7524 7964 4

Typesetting and origination by The History Press
Printed in India
Manufacturing managed by Jellyfish Solutions Ltd

CONTENTS

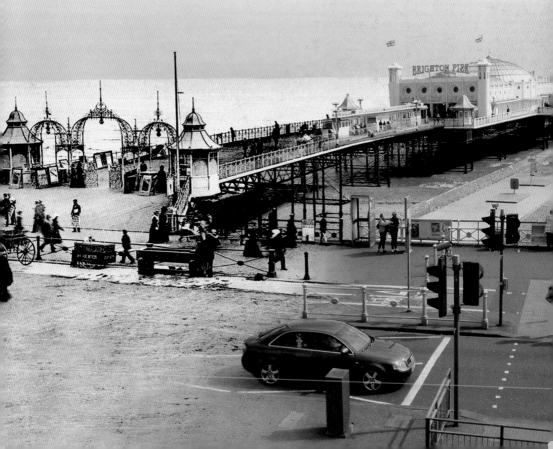

ACKNOWLEDGEMENTS

Most of the historical information linked with these photographs, old and new, is based on the work of past historians and writers. Of recent histories, I drew more on Timothy Carder's excellent *The Encyclopaedia of Brighton* than any others. Of older books, *The History of Brighthelmston: or, Brighton as I view it and others knew it, with a chronological table of local events* by John Ackerson Erredge is most entertaining. Many thanks are due to Kevin Bacon, of the Brighton & Hove Royal Pavilion and Museums, Brighton & Hove City Council, for help in sourcing the old photographs; thanks also to the always-helpful staff of the History Centre; and to the Regency Society for making the James Gray Collection of historic photographs available for this publication. I am indebted to Hattie Gordon for her ever-useful advice and enthusiasm.

ABOUT THE AUTHOR

Paul K Lyons has a long association with Brighton, and lives near Preston Circus. A business journalist for much of his life, he now spends most of his time writing about Brighton and/or diaries. His last book for The History Press – *Brighton in Diaries* – was featured in local newspapers and magazines, and called 'hugely entertaining'. He also authored *Brighton Cross*, a straight-line walk across the city, and maintains two non-commercial websites about literary and historical diaries: The Diary Review, and The Diary Junction.

INTRODUCTION

From the extravagances of the Royal Pavilion to the slums of nearby Albion Hill in the past, and from the elegance of the Regency squares to the amusement arcades on the Palace Pier today, Brighton has always been a place of high contrasts; but these contrasts exist most especially over time, as shown by the photographs in this collection.

Less than 300 years ago, Brighton was but a small fishing town, at the mercy of French raiders and wild storms demolishing its cliffs. Then, in the middle of the eighteenth century, came Dr Richard Russell, from nearby Lewes, with his new theories on the medical benefits of seawater. His ideas were widely accepted and led to a craze for visiting the seaside, rather than inland spas. Society types soon began to flock to Brighton, and even to build houses there. Royalty, too, was interested in the new fashion, most famously the Prince of Wales. He would become Prince Regent, and then King George IV, and spend decades extending and improving his Brighton home until it had become the extraordinary and flamboyant palace which still stands today. Even the stables were so grand that they now house theatres and the city's museum.

Brighton's growth in this period was phenomenal, with building for the rich along the seafront in the so-called Regency style. Brighton station opened in 1841, and the railway link brought even more intensive growth leading to cheap housing that spread out from the centre, towards Hove, Preston and Kemp Town. Increasing prosperity materialised in piers, esplanades, high class hotels and shopping, and even a beach railway. The twentieth century, by contrast, saw dramatic change for Brighton, with both commercial and residential areas being cleared for often ugly, new builds, and a growing enslavement to traffic needs. Nevertheless, Brighton – which joined with Hove and was made a city in 2000 – has held on to many treasures of the past, not least its old town in The Lanes, North Laine with its vibrant and independent shops, the elegant seafront architecture, and the exceptionally long and wide promenades.

All the old photographs in this book come from the James Gray Collection. Gray began collecting photographs and postcards in the 1950s, and during the rest of his life accumulated a huge archive. After his death in 1998, the entire collection was purchased by the Regency Society which campaigns more widely to 'treasure and preserve' the best of the past. Since buying the collection, the Society has worked to fund the digitising of all 7,500 of Gray's images, along with Gray's notes on each one.

For the contemporary photographs, my aim has been not only to show how the building, street or seafront scene looks today, but also to give a flavour of the city's cultural and social diversity and its love of festivals and artistic celebration, which often spills out into the streets.

Paul K Lyons, 2013

SEAFRONT

THIS GENERAL VIEW of Brighton's seafront, taken from Marine Parade and dating from the first half of the 1890s, looks west along Madeira Drive towards the Old Steine and the old town. A century earlier, cliffs would have been visible in the foreground, but the nineteenth century saw sea walls built and developed along the East Cliff area. Many of Brighton's seafront attractions are visible in this one photograph. The two kiosks in the foreground show the entrance to Brighton's original pier – the Chain Pier – and its suspension cables. Beyond it, and running along Madeira Drive, is the Volk's railway line. Just visible in the centre of the photograph is the clock tower, above the aquarium

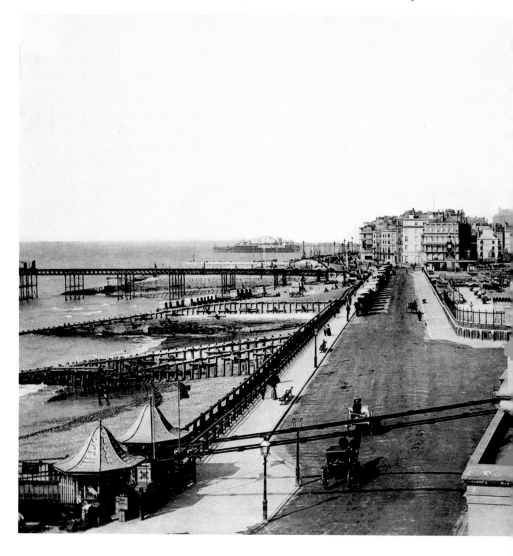

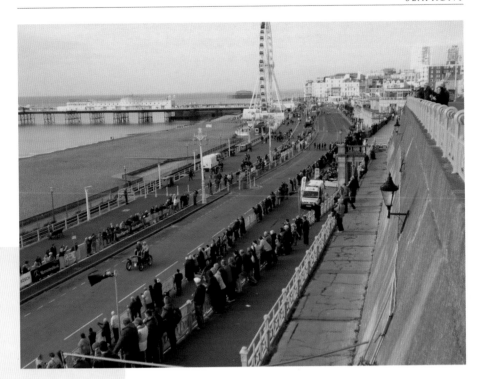

buildings, and opposite that and heading out to sea is the half-built Palace Pier. The masts of beached fishing vessels can be seen just beyond the Palace Pier construction, as can, in the distance, the flourishing West Pier.

TODAY, THE FISHING boats and Chain Pier have gone, but the seafront urban landscape remains very recognisably similar. While the distant West Pier is now but an iron skeleton isolated in the sea, the Palace Pier is a lively and popular funfair attraction. Volk's railway still runs along Madeira Drive, with its main boarding point dominated by a giant Ferris wheel, Brighton's newest attraction at the time of writing. Interestingly, the shingle beach is much wider than it was in the past. This is largely due to the construction of groynes – sea defences begun early in the eighteenth century – which accumulate shingle on their western side due to a west-to-east drift. The beaches have also widened thanks to the port authority in Shoreham, where the river Adur deposits large amounts of shingle on the west side of its estuary mouth. The authority transports the deposits, by lorry, to the east side, and they then gradually migrate along Brighton's seafront towards the marina. This contemporary photograph was taken on the day of the 2011 London to Brighton Veteran Car Run.

WEST PIER

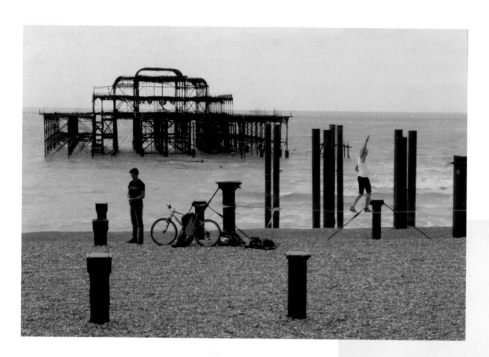

THE ONCE-MAGNIFICENT West Pier, photographed some
time between 1900 and 1910, was designed by the most
famous of pier architect-engineers, Eugenius Birch. Three
years in building, it opened in 1866; and, at 1,115ft long, it
was slightly shorter than Brighton's Chain Pier further to the
east. Initially, the West Pier had limited installations, a few
kiosks and wind shelters. In the 1890s, a new owner widened
the pier's end and erected a large pavilion with oriental
towers and seating for 1,400, as well as a landing stage for
sea craft. In 1896, wreckage from the Chain Pier, destroyed
in a great storm, caused many thousands of pounds worth
of damage. By the time of this photograph, the pavilion may
well have been converted to a theatre (1903); however, the
concert hall/middle area of the pier had clearly not yet been
added onto an expanded middle section (1916). Between the
wars, the West Pier flourished with its own resident orchestra
and a year-round programme of plays and ballets in the
theatre. It also offered many other attractions: paddle steamer
excursions, daring high divers, bathing directly from the pier,
and military bands.

IN 1940, A section of the West Pier was removed to prevent it from being used as an enemy landing point; it took until 1948 for it to be reopened. Thereafter, the pier evolved into more of a place of fun than serious entertainment. The theatre became a restaurant on one floor and a games pavilion on the other; the concert hall was converted to a tea room; and elsewhere visitors could enjoy dodgems, a helter-skelter, a ghost train and a miniature racing track. But, the pier's owners failed to maintain the structure, and closed the most southerly section in 1970. A plan to demolish the whole structure was halted by public protest and by government protection for the pier as a listed building (Grade II* and later Grade I – a building of exceptional interest). Nevertheless, the pier closed permanently in 1975. The eerie sculptural wreck visible today is the result of nearly half a century of neglect, wilful arson attacks (most recently in 2003), multifarious but failed projects to revive it, and the 2010 dismantling of the structure's beach end for safety reasons. The West Pier Trust, which has owned the pier since 1978, says construction of a new pier remains its goal, but, in the meantime, there are plans to build a 175m observation tower – i360 – on the root end of the old pier.

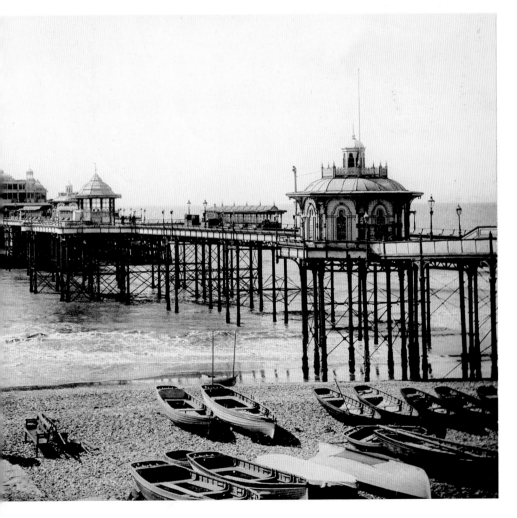

FISH MARKET

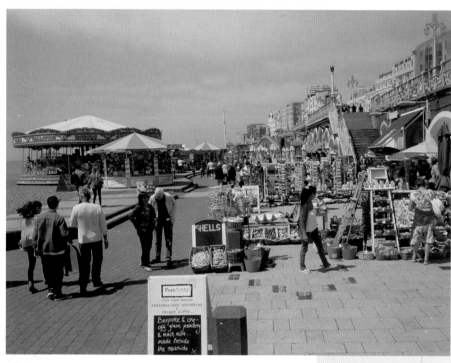

UNTIL THE EIGHTEENTH century, Brighton was nothing more than a fishing village or small town, and thus it had been for centuries, certainly since 1086 when it was first mentioned in the Domesday Book. Fishing boat numbers oscillated with the fortunes of the town – sometimes half-destroyed by storms, and sometimes overly vulnerable to French raiders. In the late eighteenth century about 100 boats were recorded as dredging for oysters in spring, and catching largely mackerel and sole in early summer, and herring in the autumn. The fish were brought to the beach in baskets, and flung down in vast heaps. Quickly, a ring of people would form, and an auction was held. Mackerel sold for anything between £1 and £7 per hundred. By the mid-nineteenth century, boat numbers had risen to 150. They declined to below 100 by the early 1900s, to no more than fifty after the Second World War, and to a small handful today. This photograph shows the fish market in the early twentieth century, when it had a hardstanding area in front

of the King's Road Arches (built in the 1880s). With the decline of the fishing industry, the market continued for a while selling imported fish, but was eventually moved by the council in 1960 to a larger wholesale market building in Circus Street.

THE KING'S ROAD Arches today house a lively and colourful collection of shops, art galleries, museums, and open-air eating areas. Arches along this part of the esplanade are currently home to Eva Petulengro, a clairvoyant and palmist, the oil painter Sheila Marshall, and a design shop called 'Posh Totty'. Nearby are the Mechanical Memories Museum, which claims to be the UK's oldest established vintage penny arcade, and the Brighton Fishing Museum, full of old pictures and artefacts tracing the community's fishing history. When the shops close up in the evening, the bars and clubs come to life – not least the Honey Club, beloved of students, and the very popular Fortune of War. The text around the top of the carousel seen in this modern photograph reads: 'O. W. Smith & Sons presents for your pleasure and delight a set of 1888 golden galloping horses.' And each of the horses has its own name, such as Gemma and Gerald.

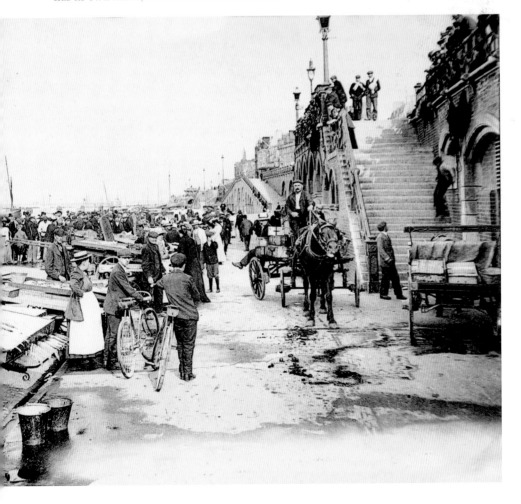

KING'S ROAD

PRIOR TO THE nineteenth century, there was only a rough track running along the top of the cliffs, and below was the beach. A sea wall, a lower promenade and the King's Road were first laid down in the 1820s with the help of the architect, Amon Henry Wilds, and with money from King George IV (who opened the road – hence the name). The distant building on the right was Markwell's Royal Hotel, built in 1870; but, around 1909, it was absorbed into its neighbour, Queen's Hotel. At the time of this photograph, 1890, the businesses operating in the block nearest Markwell's included: a milliner and ladies hatter, a pianoforte depot, a lace warehouse, a furrier, a 'fancy jeweller', and a photographer. Not quite visible along the parades of grand houses are the entrances to Little East Street, Black Lion Street

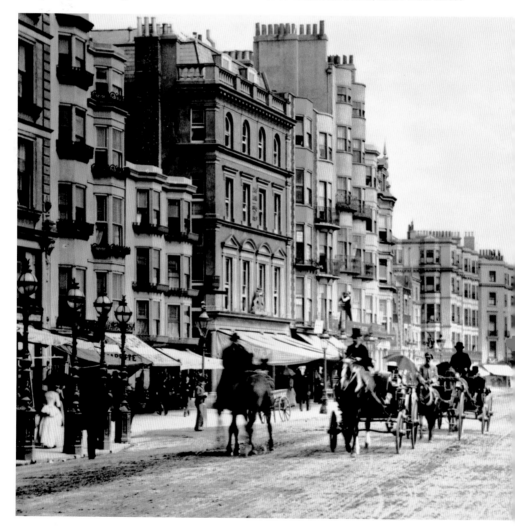

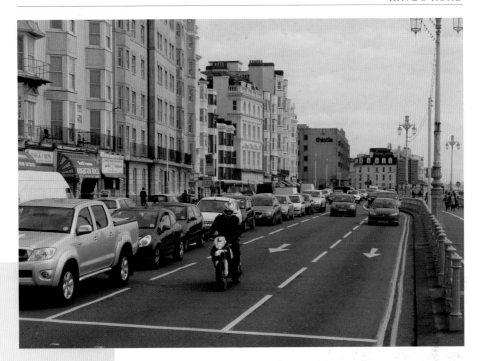

and Ship Street. Near to the latter was (and is) the famous Old Ship Hotel, the oldest licensed house in Brighton, probably dating from the early 1600s. Other shops along King's Road at the time were selling silk, silver, diamonds, baby linen and oysters. There was also an India rubber manufacturer. According to James Gray, the four ornamental lamps to the left of the photograph were a bit of mystery since they usually stood outside the mayor's residence yet there was no mayor living there at that time.

THIS IS THE traffic-busy King's Road today, looking east from West Street. A pink-tarmac cycle path runs along the pavement on the beach side, often over-run with pedestrians on busy days. The western façade of the Queen's Hotel is clearly visible, as are many of the buildings from over a century ago. West of the Queen's Hotel is one of the few modern buildings on this stretch of King's Road – the Thistle Hotel, built in the 1980s, with its green glass and geometric design. Over time, the Old Ship Hotel has taken over all the other buildings in the block, from Black Lion Street to Ship Street. A parade of shops selling fish and chips, Brighton rock, and Italian food fills the next block along, from Ship Street to Middle Street. And nearest the foreground are two large blocks of flats, one managed for students, and yet more seaside-type shops.

AQUARIUM AND WHEEL

THIS 1896 PHOTOGRAPH is attributed to Francis Frith & Co., in Reigate, the world's first specialist photographic publisher, and creator of tens of thousands of scenic postcards. The central building, dominated by a clock tower, housed the Brighton Aquarium, brainchild of the pier engineer, Eugenius Birch. Construction was a major undertaking, requiring a new sea wall and road, and a main aquarium hall with a vaulted ceiling supported by granite and marble columns. On opening in 1872, it boasted the world's largest display tank. Soon after, a roof terrace and clock tower completed the external appearance, as in the photograph. An octopus and sea lions were among the early attractions, and the aquarium proved a huge success. By the turn of the century, though, the business had run into financial difficulties. It was sold to Brighton Corporation which managed to run the enterprise with some success, offering, at various times, additional entertainments such as music and films. In the late 1920s, the corporation invested heavily in a rebuild, using white stone, and removing the

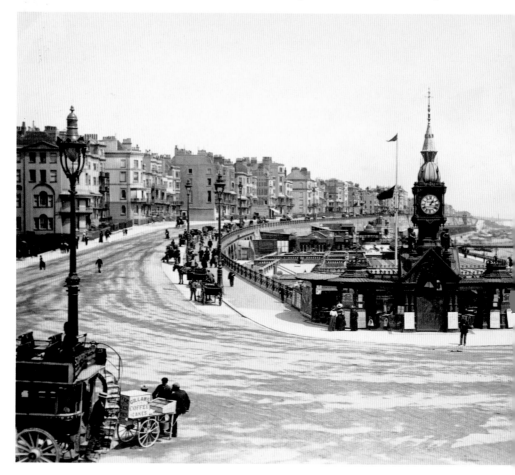

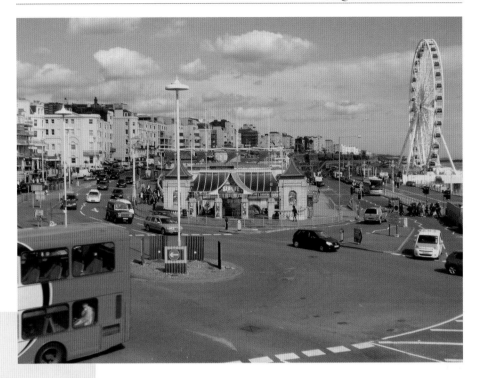

clock tower (it was moved to the entrance of the Palace Pier). A ballroom and bandstand were added to the sun terrace. The Chain Pier is clearly also visible in the Frith photograph; and James Gray notes the contrast between the recently erected electric light standards on Marine Parade and the small gas lamps on Madeira Drive.

THE LATEST INCARNATION of the original aquarium – Brighton Sea Life – is owned by Merlin Entertainments Group which also owns other Sea Life centres in UK and Europe, and attractions like Alton Towers and the London Eye. The building's facilities have undergone many transformations through the twentieth century, serving as a nightclub, a ballroom, a motor museum, and a venue for chimpanzee tea parties. Before becoming Sea Life in 1991, however, it served as a dolphinarium which, though popular to begin with, latterly suffered much from local protest. Although the modern photograph is very clearly of the same scene as that in the Frith view, the once apparently peaceful junction is now a very busy roundabout. To the right is the Brighton Wheel, the city's newest landmark at the time of writing. Manufactured in Germany, the Wheel was first erected in South Africa as a tourist attraction during the 2010 World Cup, and it was brought to Brighton in the autumn of 2011. The council has granted permission for it to operate until 2016.

PALACE PIER

DESIGNED BY RICHARD St George Moore, Brighton
Marine Palace – referred to for most of its history as the
Palace Pier – took nearly twenty fraught years to build.
The developers had underestimated the complexity of
construction, and then, when the half-built structure
was seriously damaged by the old Chain Pier breaking
up in the 1896 storm, they were ready to give up and
liquidate the company. The project was saved by the
railway entrepreneur Sir John Howard. The pier finally
opened in 1899, spectacularly illuminated by 3,000 light
bulbs (today there are over 60,000), and it proved a huge
success. This early twentieth-century photograph shows
the pier in its near original state, before construction of
a central wind shelter, bandstand, and a Winter Garden
near the shore end, all of which came prior to the First
World War. A new entrance, with clock tower, was
inaugurated in 1930; and towards the end of the same
decade, the pier recorded 2 million visitors in one year.

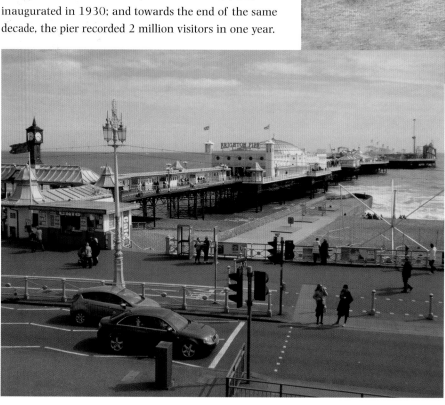

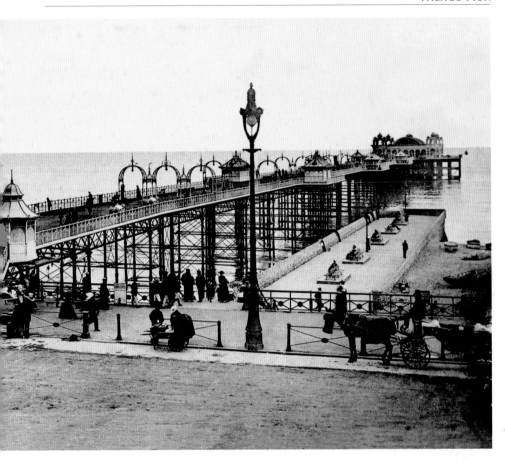

As with the West Pier, a section was cut out during the Second World War to foil any attempt to use it for a landing. Some consider the Palace Pier to be the finest pier ever built.

AFTER THE WAR, the Palace Pier remained popular, offering summer shows with the likes of Dick Emery and Tommy Trinder and regular concerts in the Winter Garden. It also provided the setting for one of the most exciting scenes in the famous 1947 film of Graham Greene's novel *Brighton Rock*. In 1984, the pier was bought by the Noble Organisation, a gaming conglomerate, which introduced free admission and new attractions. Noble has tried to rename the attraction Brighton Pier – as can be seen in the photograph – though many, including the local newspaper, still call it the Palace Pier. One of the two original kiosks, first used for the Chain Pier, is visible on the very left of the photograph, as is the old Winter Garden, now an amusement arcade (but still sporting the beautiful stained-glass windows), and the funfair at the pier head. The tall vertical structure is a ride called The Booster, constructed in 2006. Also on the pier can be found the Palm Court, said to be the 'spiritual home' of fish and chips, and Horatio's Bar, which hosted a Brighton Festival performance event in 2012.

OLD CHAIN PIER

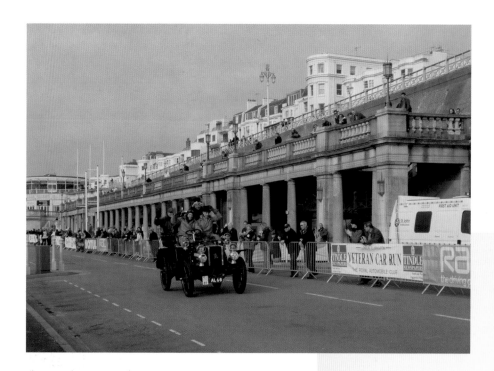

THE ROYAL SUSPENSION Pier – otherwise known as the
Chain Pier – opened in 1823, principally as a landing
stage for packet boats to France. However, it was also
open to promenaders, and soon became a very popular
attraction. Unfortunately, it was not able to stand the
ravages of storms, and having been damaged several
times before, was finally destroyed in 1896. The old
Chain Pier buildings visible in this old photograph lasted
another thirty years. The large house in the centre
was originally used as a lounge or reading room, and
then, for many years, it became Snelling's Bazaar – Mr
Snelling being secretary of the company that ran the
pier for nearly thirty years. The cottage to the left of
the main building (later known as Beach Lodge) was
occupied by the first Pier Master. The buildings were only
removed in 1927, just after this photograph was taken,
to allow for an extension of the already existing Madeira
Terrace – a kind of mezzanine promenade that ran above
Madeira Drive but below Marine Parade. Although

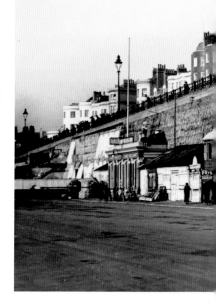

several decades old by this time, Madeira Terrace only ran from just west of this photograph (hence the steps) as far as Duke's Mound; the extension would take it all the way to the aquarium.

THIS VIEW OF Madeira Drive today, looking west past where the Chain Pier buildings used to be, shows the Madeira Terrace extension (a popular place to watch the main events that take place on Madeira Drive) as well as the largely unchanged profile of buildings at the western end of Marine Parade. This photograph – like the first in the book – was taken in November 2011 on the day of the London to Brighton Veteran Car Run, perhaps the most famous of Madeira Drive entertainments, since it was immortalised in the 1953 film comedy, *Genevieve*. The annual drive commemorates the 'Emancipation Run' of 14 November 1896 when thirty-three motorists set off from central London to Brighton to celebrate a law that raised the speed limit from 4mph to 14mph. Less than half survived the rough roads. The car in this photograph is a French Panhard et Levassor dating from around 1900 and was entered by Jeremy Stubbs.

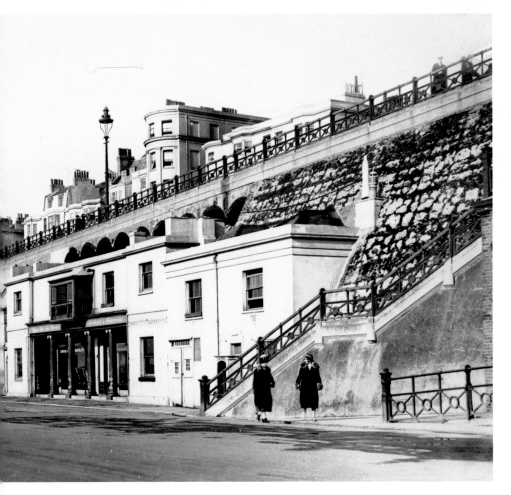

VOLK'S RAILWAY

MAGNUS VOLK, THE son of a German clockmaker, was a Brighton inventor fascinated by electricity and telegraphy. He is said to have been the first resident to install electric lighting in his house, and that this led to him being given a contract to provide the Royal Pavilion with electric incandescent lighting. In 1883, he opened his pioneering narrow gauge electric railway. Initially, it only extended ¼ mile from opposite the aquarium to the Chain Pier. On being refused permission to extend it westward, he lengthened the line to the east, as far as the Paston Place or Banjo Groyne (a concrete groyne about halfway to Black Rock). The line then had a total length of nearly a mile, and it had one loop for the two cars to pass in the middle. Volk also built another railway line that ran through the sea from Brighton to Rottingdean using a large car, more like a boat's deck, with very tall legs – the Daddy Long Legs. This operated for only a few years, proving less than viable

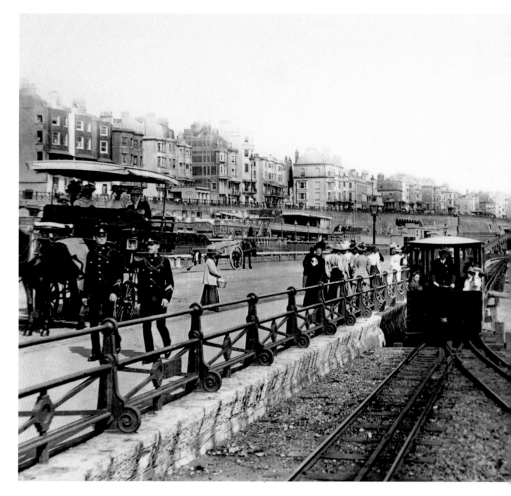

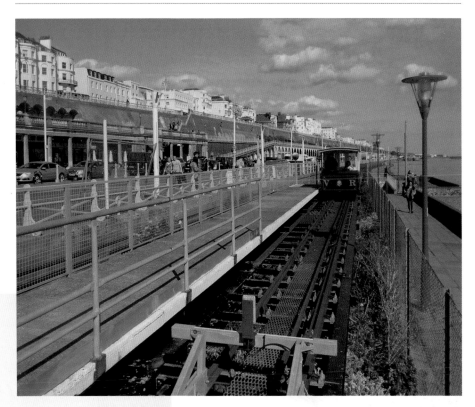

technically and financially. Volk then won permission for an extension of his electric railway to Black Rock, which opened in 1901, and increased the line's length to 1¼ miles. The photograph, looking east from near the aquarium terminus, dates from around 1910.

TODAY, VOLK'S CLAIMS to be the 'world's oldest operating electric railway', and is one of Brighton's major attractions. Having undergone various alterations over the years, it still runs from a station just west of the aquarium and continues to Black Rock, near the marina, with a halfway halt. None of the original cars are extant but two from the early 1890s are being rebuilt, according to the railway's website, at the time of writing. The several cars in service date mostly from the early twentieth century; and an association of volunteers – VERA – helps restore, promote and operate the line. A return fare costs £3.10.

MADEIRA DRIVE

LOOKING WEST FROM near where Paston Place meets
Marine Parade, this photograph shows Madeira Drive in
the early 1920s when Madeira Lawns was thriving with
bowling greens, gardens, a bandstand and theatrical
entertainments. Also visible are both the Palace Pier
and West Pier in the distance, Madeira Terrace, and
the picturesque Madeira Lift which gave access to a
Shelter Hall below in Madeira Drive. The Madeira Lawns
– indeed much of Madeira Drive – was an area of land
reclaimed thanks to the build-up of shingle on the beach
caused by the Banjo Groyne, constructed in 1877.
Jack Sheppard's Entertainers was one of the most
popular shows on Madeira Lawns before and after
the First World War. Jack, whose real name was
Frank Gomm, formed a band of four singers, called
The Highwayman, each one dressed as a notorious

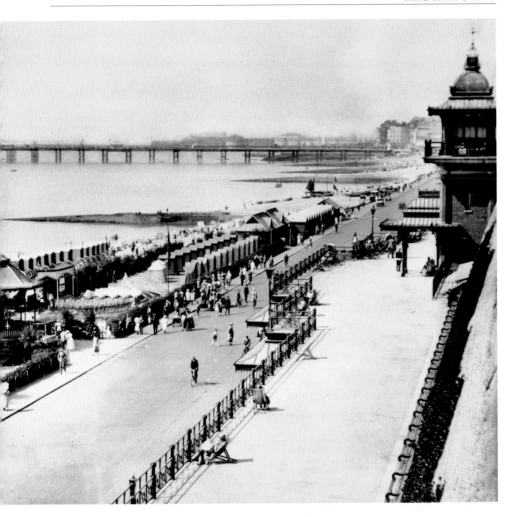

character from history – Dick Turpin was one, and Jack Sheppard, played by Frank, was another. The band gave Max Miller – one of Brighton's most famous theatrical figures (of whom there is a statue in New Road) – his first job in 1919.

THE SAME AREA of seafront today looks neglected and unused. Having been closed off during the Second World War, it was home to Peter Pan's Leisure Park for years but suffered a fire in the late 1980s. At the time of writing, Brighton & Hove Council was considering various options for redeveloping the area. On the left of the photograph can be seen a corner of Yellowave, the country's only permanent beach venue of this type. The facility's main focus is on beach volleyball – indeed it was included as an official 2012 Olympics training camp – but it also offers a children's sandpit, a climbing wall and a café. East of Yellowave is the Peter Pan playground and an adventure golf course. Although the old Madeira Lift was out of service for many years, in 2008–2009 the council invested £250,000 to bring it back into use.

MARINE PARADE

THIS TURN-OF-THE-CENTURY view of Marine Parade looks east from Charlotte Road to
Royal Crescent, roughly halfway between the Sea Life Centre and Paston Place. The nearest
building, in red brick and knapped flint, was called Hartland House at the time of the
photograph. It was designed – somewhat out of keeping with much else on the seafront – by
Sir Robert William Edis who also designed the Great Central Hotel by Marylebone station
(now called the Landmark London). In the distance can be seen the Royal Crescent Hotel
which sits on the eastern side of Royal Crescent itself. In between were several other hotels,
including Bedford House (a small house built by the Duke of Bedford), and Paragon House.
The Royal Crescent, a series of bay-fronted terraced houses faced with black glazed tiles
(just out of view), completed in 1807, was the earliest unified composition of buildings to be
constructed in Brighton.

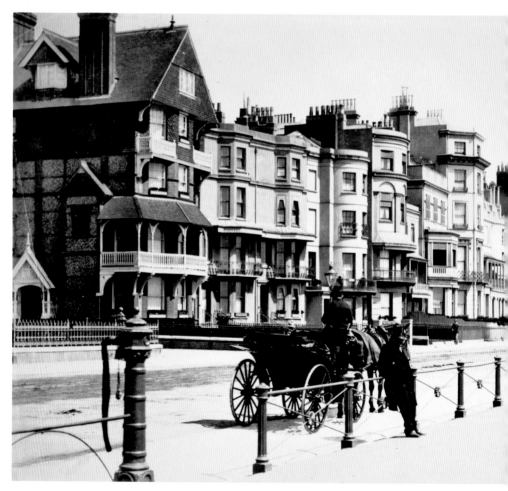

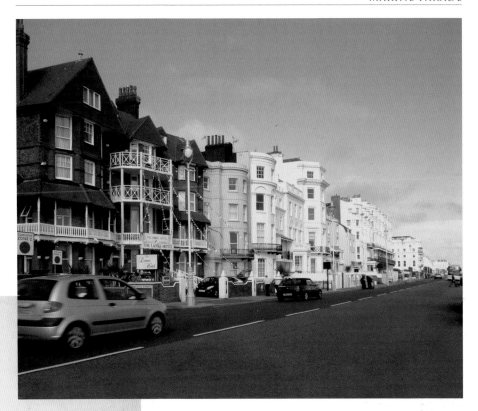

THIS FINE SET of buildings on Marine Parade is virtually unchanged from a century or more ago. The nearest one (several balconies added) was listed for many years as 'Langley, private hotel' then it became Langley Court Hotel, and today it is The Lanes Hotel (although this is a slight misnomer since its location is half a mile from The Lanes!). Apart from the three or four hotels, the buildings further along have been largely used as residences. The fourth house along from The Lanes Hotel, with a flat frontage, is Tamworth House. This was owned by the British Legion for much of the twentieth century, but in 2004 it was sold to a developer who converted it to flats, and in doing so uncovered a secret tunnel from the basement to Madeira Drive. A little further east, Bedford House, has had at least two famous owners: D'Oyly John, a South African born painter, sometimes dubbed the Van Gogh of Brighton; and the dramatist, Sir Terence Rattigan, who co-authored with Graham Greene the screenplay for *Brighton Rock*. During the 1960s and 1970s, the actor Laurence Olivier owned a house further along, in Royal Crescent.

METROPOLE AND GRAND

HERE ARE TWO of Brighton's largest and most impressive buildings – the Metropole Hotel on the left, and the Grand Hotel on the right. Opened in 1864, the Grand was designed by John Whichcord Jr in the Italian style, with bronzed and gilded balconies, elaborate decoration, and two corner towers. As befitted the name, it was the biggest and tallest building in town, and was among the first hotels in the country to install electric lighting and lifts. The Metropole, in red brick and terracotta with a central copper spire and turrets, was designed by Alfred Waterhouse (who also designed London's Natural History Museum). This photograph shows it in the 1890s, just a few years after its completion. At the time,

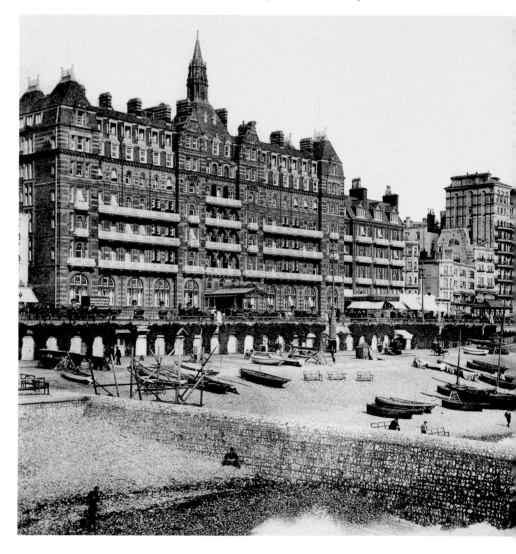

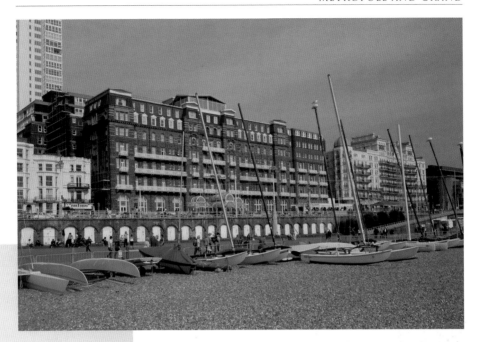

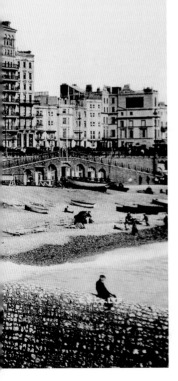

some thought it the town's ugliest building – the red brick contrasting with the traditional seafront cream colour – but it also had the most extensive extras of any hotel outside London, boasting various vapour baths and conference facilities.

BETWEEN THEN AND now, both hotels have seen much change and a good deal of history. Before any architectural changes, though, in the mid-1930s, the Metropole was advertising itself as 'renowned for its unexcelled cuisine, service and comfort' with tennis, dancing, angling, golf, Turkish and Russian baths, and special inclusive rates from 6½ guineas a week. The Grand called itself 'Brighton's most comfortable hotel' with the 'finest position on the front' and offered inclusive terms from 5½ guineas a week. During the Conservative Party Conference in 1984, a bomb in room 629 planted by the Provisional IRA failed to assassinate Prime Minister Margaret Thatcher but killed five people and left huge damage to the building. The owners, De Vere Hotels, subsequently refurbished and rebuilt parts of the building, including raising the western annexe. The Metropole, which was used as a base for Australian and New Zealand forces during the war, underwent its own transformation in the early 1960s, when two stories were added for the loss of the spire and turrets. Today it is on lease to the Hilton Group.

REGENCY SQUARE

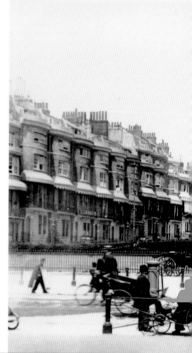

BRIGHTON IS RENOWNED for its Regency architecture, and Regency Square is one of the city's pearls. It was built between 1818 and 1828 over Belle Vue Field. The field had previously been the site of a windmill, various fairs, and large military camps (as mentioned in Jane Austen's *Pride and Prejudice*). Joshua Hanson, a property speculator, bought the area, divided it into seventy plots and then sold them individually with strict building covenants to ensure architectural harmony. Many of the houses were designed by the famous Brighton architects Amon Wilds and his son Amon Henry Wilds. This photograph was taken in 1902, nearly a century after the square was built, and about twenty years after Brighton Corporation took over and extended indefinitely the covenants. At the time, local street directories show, more than half of the buildings were lodging or boarding houses.

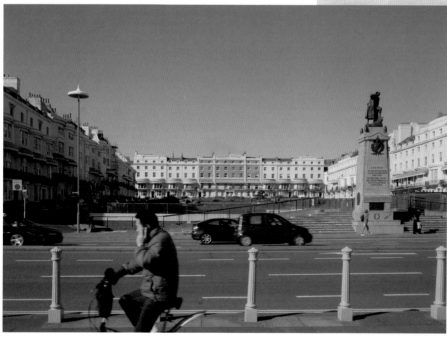

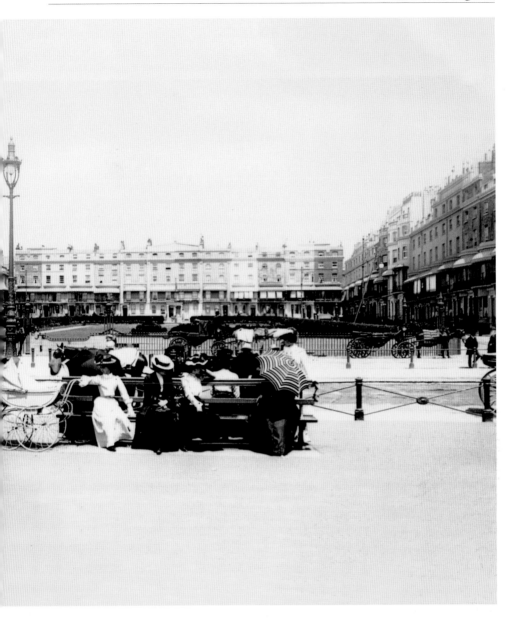

TODAY, REGENCY SQUARE retains most of its original charm thanks in part to the covenants, their English Heritage Grade II or II* listing, and to the efforts of the Regency Society, a Brighton conservation group. In the early 1970s, many of the hotels wanted to erect neon signs, and so the Society negotiated the establishment of a Conservation Area based around the square. At the same time, a plan to build a surface car park was modified into an underground facility. The statue – South African War Memorial – was erected in 1904 to remember men of the Royal Sussex Regiment who died in the Boer War, but also commemorates men lost in the two world wars.

29

KING'S ESPLANADE

THIS IS KING'S Esplanade in Hove, a little under 2 miles west of the Palace Pier, in 1907.
The 1,000ft of promenade – originally Medina Parade – was built in the 1880s at a cost
of around £11,000, inclusive of new groynes. Part of the scheme involved construction,
by a private company, of public baths, and these opened in 1894. There was a men's bath,
a women's bath in a separate building and a slipper bath, plus a laundry. Residents of St
Aubyns Mansions (just visible in this 1907 view) were said to grumble about the black
smoke issuing from the laundry's chimneys. Two years after this photograph was taken, the
baths were being promoted for medical cures – an advertisement in the town directory called
them the 'Hove New Turkish Medical and Electro Hydropathic Baths Co. Ltd'. By 1919, they
had been taken over by the Hove authorities.

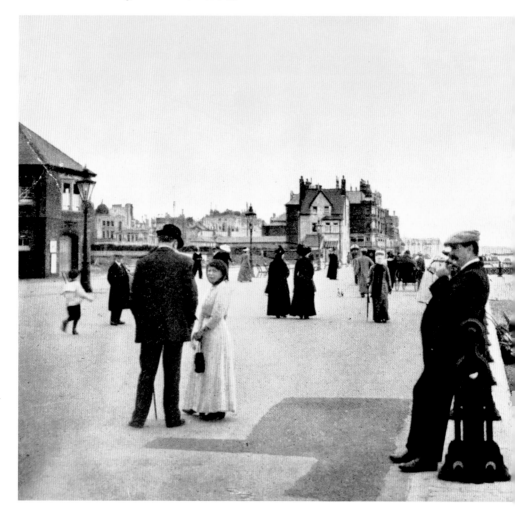

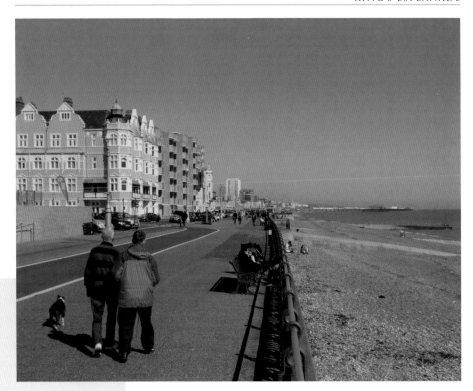

APART FROM THE addition of a cycle lane, the esplanade is little altered today. The buildings, though, have changed considerably. The large and now aged King Alfred's Leisure Centre (so named because it was requisitioned by the Navy as HMS *Alfred* during the last war) is just out of view to the left. St Aubyns Mansions – painted yellow and white – was stuccoed after the First World War; and, during the Second World War it also became part of HMS *Alfred*, but remained semi-derelict for several years, before being restored. Two famous stage performers have lived there: Dame Clara Butt, a contralto singer, and Vesta Tilly, a male impersonator and music hall entertainer. Next door to St Aubyns Mansions is the modern apartment block, Bath Court. This was built on the site of the old swimming baths in the early 1890s. However, one section of the old baths, just beyond Bath Court, was owned by a diamond merchant for many years, with a workforce of up to fifty. It fell into disuse and was squatted in the late 1990s by a group of artists, who were eventually evicted. Various plans for a block of flats on the site have failed to win planning approval. Next to the unused Medina House, stands Maroccos, famous for its Italian ice cream since 1969.

TOWN HALL

IN THE 1770s, Brighton commissioned its first market building for the daily sale of meat, fish, poultry and garden produce. It thrived and expanded until the 1820s when a decision was taken to knock it down so as to build the present Town Hall. A new market building was also constructed nearby. Brighton's Town Hall, designed by local architect Thomas Cooper in the form of a Greek Cross with two-storey porticos on each of its four arms, opened in the early 1830s. However, the southern arm was never completed. The giant-fluted Ionic columns above the smaller Doric columns looked top heavy, and the building opened to much criticism, such as 'Designed after a day trip to Greece'. The interior had classical pretensions, too, with columns, large halls, corridors and staircases. A debating chamber on the second floor, which adjoined the Great Room, was said to hold 800. The building was

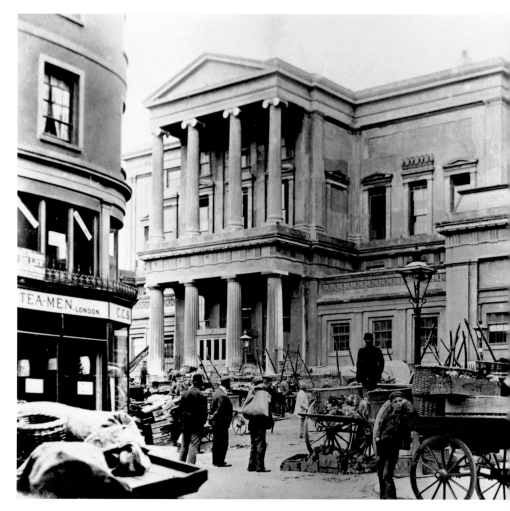

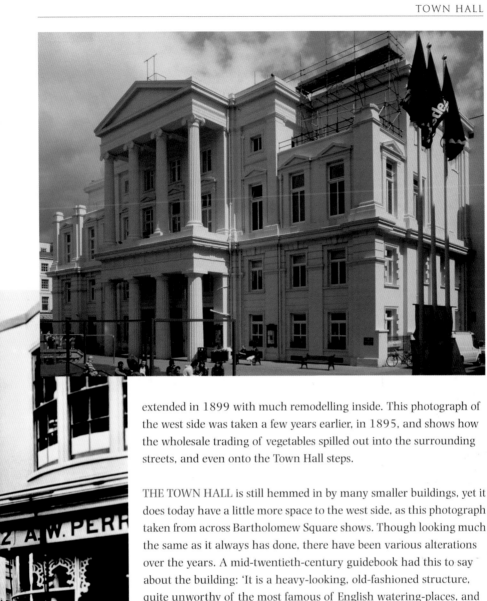

extended in 1899 with much remodelling inside. This photograph of the west side was taken a few years earlier, in 1895, and shows how the wholesale trading of vegetables spilled out into the surrounding streets, and even onto the Town Hall steps.

THE TOWN HALL is still hemmed in by many smaller buildings, yet it does today have a little more space to the west side, as this photograph taken from across Bartholomew Square shows. Though looking much the same as it always has done, there have been various alterations over the years. A mid-twentieth-century guidebook had this to say about the building: 'It is a heavy-looking, old-fashioned structure, quite unworthy of the most famous of English watering-places, and ere long it will doubtless be replaced by a more up-to-date building'. Such an outcome is unlikely since the Town Hall now has a Grade I listing. The council continues to employ it for various services not least as a Register Office and to hold civil ceremonies for which are offered, apart from the Office itself, two fancy rooms: the Regency Room which is decorated with heritage colours, antique furniture and crystal chandeliers; and the Victorian-style Mayor's Parlour with carpet from the Royal Pavilion.

BLACK LION STREET

BLACK LION STREET, which runs south from The Lanes area to the sea, dates at least from the mid-seventeenth century. In 1889, two years after this photograph was taken, the old houses on the east side, those that backed onto the market, were removed to widen the street. Two of Brighton's most historic beer-related buildings can be seen on the west side. The Black Lion Brewery – obvious from the lion weathervane above the gable front – can be traced back to the middle of the sixteenth century, and the time of King Henry VIII. The brewery was bought or set up by a Flemish Protestant called Deryk Carver, but when

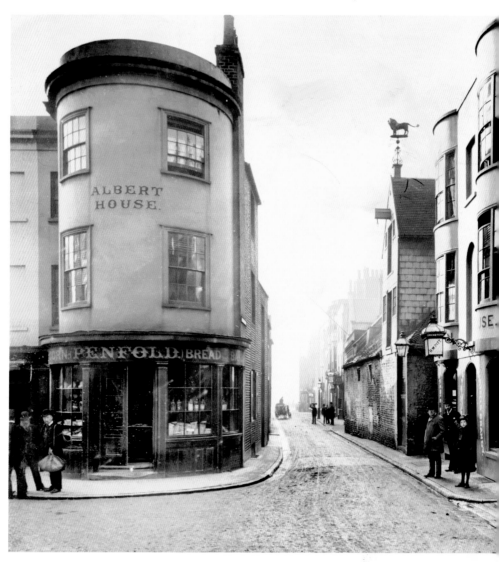

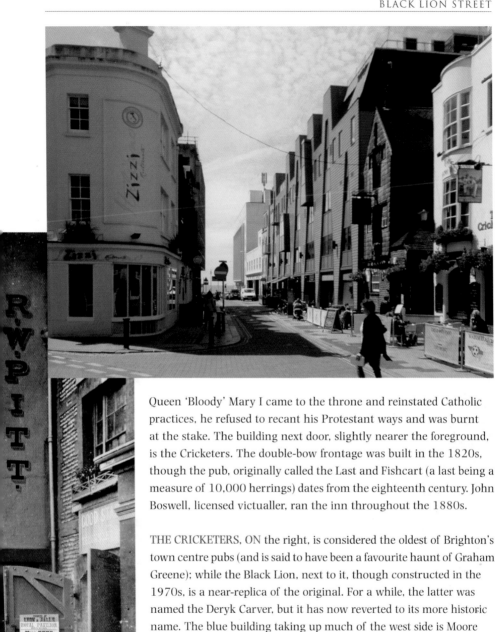

Queen 'Bloody' Mary I came to the throne and reinstated Catholic practices, he refused to recant his Protestant ways and was burnt at the stake. The building next door, slightly nearer the foreground, is the Cricketers. The double-bow frontage was built in the 1820s, though the pub, originally called the Last and Fishcart (a last being a measure of 10,000 herrings) dates from the eighteenth century. John Boswell, licensed victualler, ran the inn throughout the 1880s.

THE CRICKETERS, ON the right, is considered the oldest of Brighton's town centre pubs (and is said to have been a favourite haunt of Graham Greene); while the Black Lion, next to it, though constructed in the 1970s, is a near-replica of the original. For a while, the latter was named the Deryk Carver, but it has now reverted to its more historic name. The blue building taking up much of the west side is Moore House, a mixed-purpose development. At street level there are two restaurants, one Italian run by Jamie Oliver, and the other Vietnamese. Zizzi, in the curved corner building, reminiscent of the old Albert House, is part of a nationwide chain of Italian restaurants owned by the Gondola Group. Brighton's first and most famous vegetarian restaurant, Food for Friends, can be found just behind where this photograph was taken, on Prince Albert Street.

THE LANES

BRIGHTON'S OLD TOWN developed largely within the boundaries of North, East and West Streets, and King's Road. At the heart is an area called The Lanes, characterised by very narrow alleys and twittens, reminiscent of a medieval town. Mostly, the oldest buildings date only to the eighteenth century, but some of them may have been refaced or rebuilt from late sixteenth-century or early seventeenth-century developments. This photograph of an ironmonger's shop at No. 44 Market Street was taken around 1900, and shows part of a large building – the Pump House. Though thought to be one of the oldest houses in The Lanes, much of what is visible – the black-tiled façade and bow

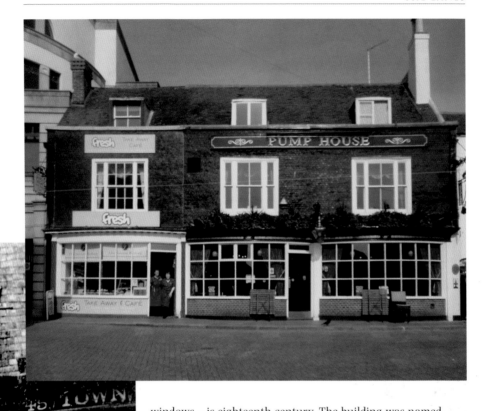

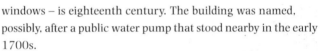

windows – is eighteenth century. The building was named, possibly, after a public water pump that stood nearby in the early 1700s.

TODAY, THE LANES is a thriving shopping area and tourist attraction, full of jewellers and cafés, as well as antique, gift and art shops – 'boutique fashion' according to Brighton & Hove's tourist office. This was not always the case, however, since between the wars the area was shabby and run-down, and was not even mentioned in guidebooks of the time. Redevelopment plans were drawn up, but were never enacted. The Pump House building looks much the same as it did a century ago. Most of it is now a pub owned by Nicholson's. Company advertising says there is a stone fireplace inside bearing the initials of Miss Elliot, who bought the building in 1766; it also says the cellars date from medieval times. Next door, the old ironmongers store is now a Forfars bakery. Forfars, which has some twenty shops mostly in and around Brighton, has been run by the Cutress family since 1936, and, in 2012, celebrated its 75th anniversary. The Cutresses claim to have been milling and baking in Sussex since the 1500s! Standing in the doorway are Jean and Gloria.

OLD STEINE

FOR CENTURIES, THE area visible in this photograph – called the Steine, probably meaning a place of stones – was where the Wellesbourne, a small stream, ran out towards the sea. Devoid of trees, ill-drained, and often waterlogged, fishermen used it to lay out their nets or store their boats, and townsfolk used it for pasture. As Brighton became more fashionable and popular, so improvements were made to the flat area, with turf and drainage, to allow visitors and residents to promenade. The land was enclosed with railings and lit with gas in the 1820s, thus denying the fishermen their net-drying areas. The fountain, with its supporting dolphins, was designed by the architect Amon Henry Wilds, and erected in 1846. Impressive buildings emerged on all sides, not least the two large hotels, the Royal York and Royal Albion on the south side (out of view). Most of the buildings seen here, on

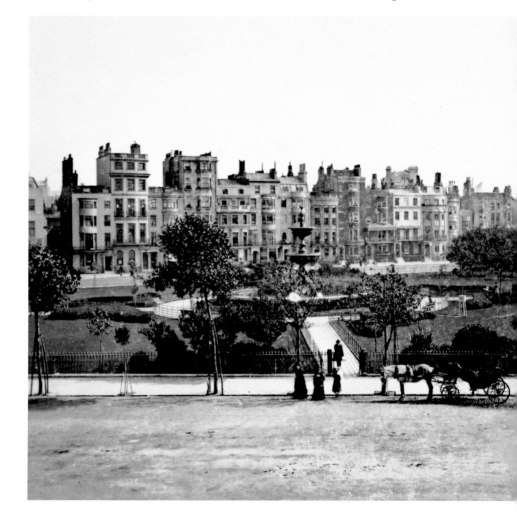

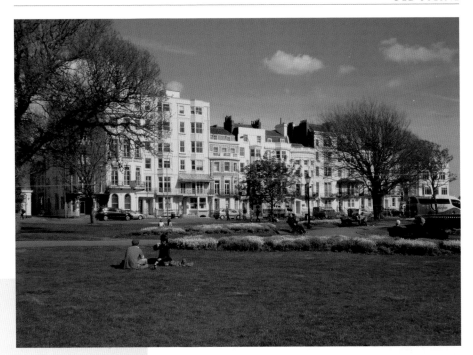

the east side, were constructed in the late eighteenth and early nineteenth centuries. By 1890, around the time this photograph was taken, many were owned by surgeons and dentists. The second (tall) house from the left was home to Dr Gideon Mantell in the 1830s. Though he wished to make his mark as a doctor among Brighton's high society, it was the extraordinary collection of fossils he kept in his house – he is credited with beginning the scientific study of dinosaurs – that attracted the nobility's attention.

TODAY, THE AREA known as Old Steine is surrounded by busy roads. The attractive lawns, flowerbeds and fountain remain, as do the Royal York and Albion hotels (to the right of and behind where this photograph was taken). For many years, until the last major refurbishment in the 1990s, the fountain was lit at night by an array of coloured lights. The buildings visible are now all, or almost all, divided up into flats and office premises. At ground or basement level there are several nightclubs and bars (Revenge and Vavoom), a solicitor, and the European School of Animal Osteopathy and Equine Dentistry. Events occasionally take over the gardens, especially during the annual Brighton Festival.

NORTH STREET

IN THE LATE nineteenth century, North Street was a busy and prosperous place. The striking clock tower in the middle of this 1894 photograph was erected several years earlier to commemorate Queen Victoria's Golden Jubilee. Designed by John Johnson – who is credited with only a few other notable works such as Staines Town Hall and St Matthew's Church in Bayswater – it stood 75ft high with a time ball above its cupola and four clock faces. The time ball, created by none other than Magnus Volk, was made of copper, and was controlled by an electrical signal from Greenwich. It rose steadily and

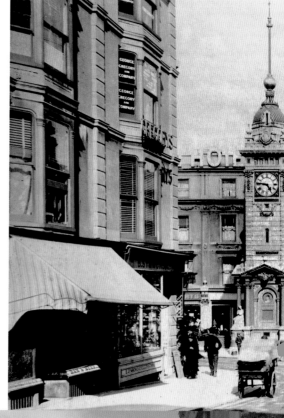

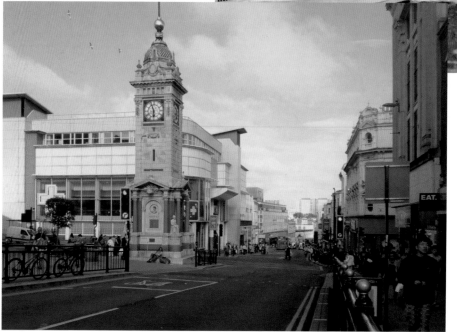

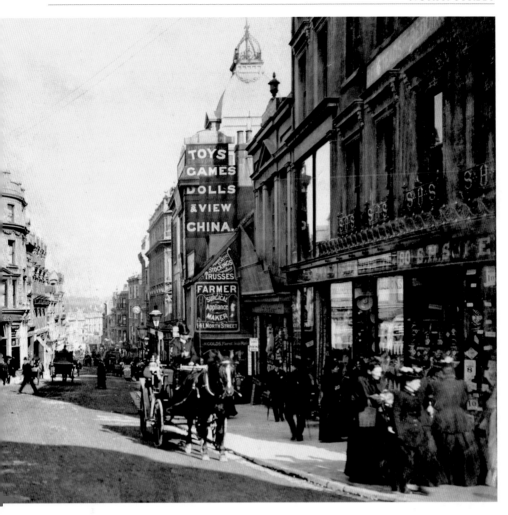

then dropped on the hour. However, it proved too noisy and was decommissioned within a few years. The base holds four porticos with medallion portraits of Queen Victoria and her family, each framed by red granite columns.

WHEN WANDERING AROUND present-day Brighton, the clock tower feels very much like its centre. On either side of North Street, there are North Laine and The Lanes respectively, and, at its lower end, the Old Steine opens out. From the clock tower, Queen's Road runs up to the station, and the seafront is just a short walk along West Street. Behind where this photograph was taken is Churchill Square, the city's busiest shopping centre. The clock tower is more or less unchanged, but North Street has become an unattractive conglomerate of banks, clothing stores, cafés, and tourist shops. The large building in white and green glass behind the clock tower houses a large Boots. Although some effort has gone into making the junction more pedestrian friendly, it remains dominated by a never-ending stream of buses and taxis.

CHURCHILL SQUARE

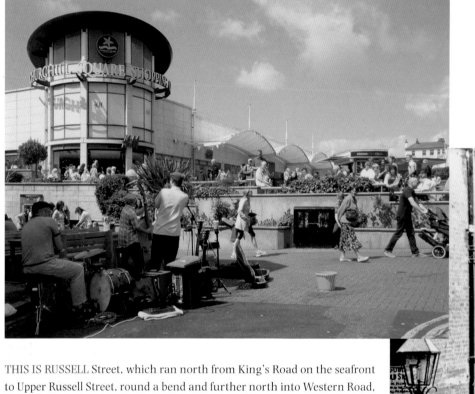

THIS IS RUSSELL Street, which ran north from King's Road on the seafront to Upper Russell Street, round a bend and further north into Western Road, very near the clock tower. The building on the left of the busy scene was built as a church, but at the time of this photograph in the early 1920s, it was already serving as the town's meat market. Revd Henry Wagner, the Anglican vicar of Brighton for much of the middle part of the nineteenth century, and his equally rich and charitably minded son, Arthur, sponsored a dozen or so churches in Brighton. This one, the Church of Resurrection, dating from the 1870s, was meant for fishermen and the poorer people in the congested seafront area. An adjacent business – the Cannon Brewery – objected to the proposed height, and so, unusually, the floor stood considerably below ground level, with the entrance giving on to a balcony at the south end. By 1912, it had closed; thereafter, the building housed a meat market until the 1960s. The densely packed streets around were full of pubs, at least five in Russell Street itself. Arthur Wagner, incidentally, was also responsible for St Bartholomew's Church, near London Road, with the largest nave of any parish church in Britain.

BRIGHTON'S AUTHORITIES FIRST conceived of rebuilding the town's central area with a new complex before the Second World War. A few buildings in Upper Russell Street and elsewhere were cleared at the time, but Russell Street itself survived another twenty years. The whole area – bounded by Western Road, West Street and King's Road up to Cannon Place (but not including the Grand Hotel) – was razed in the late 1950s and early 1960s. In its place came one of Britain's last outdoor shopping centres – opened in 1968 – and associated facilities, such as an underground car park. A local paper – *The Argus* – later described it as 'a windy, bleak collection of shops and cul-de-sacs'. In the mid-1990s, Standard Life took over the site, and pumped nearly £100 million into creating the covered Churchill Square centre of today. The precise space that used to be occupied by Russell Street is now buried somewhere inside the shopping complex on the east side. A rhythm & blues trio, Red Jackson, is busking in the foreground.

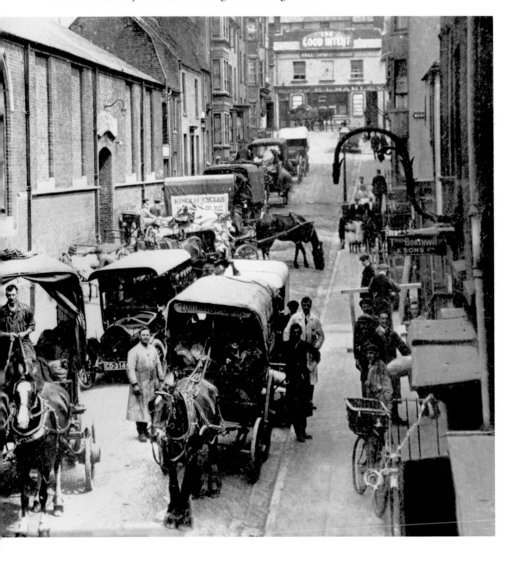

WEST STREET

UNTIL THE EIGHTEENTH century West Street marked the western limit of the old town. By the time of this photograph (1880s) it had become a thriving commercial thoroughfare – being the most direct route from the station to the seafront – with the Seaview Coffee & Dining Rooms on the left and the Chatfield Hotel on the right. Next to the hotel stood a concert hall – the tallest building in the row. This had been built on the site of a house that had stood for 100 years previously and had been owned by Henry Thrale, friend to many literary types, such as Dr Samuel Johnson and Fanny Burney. After ten years or so, the concert hall was converted to a roller-skating rink, then a 2,000-seat cinema for a few years, and then into Sherrys Dance Hall. The spire of a Gothic-style church, St Paul's, is just visible at the top left-hand corner of the photograph. Set back from the road, it was opened in the 1840s by Henry Wagner again, who appointed his son Arthur as curate. The Church of Resurrection (Russell Street), when it opened in the 1870s, was less than 100ft away.

WEST STREET TODAY is an architectural hotchpotch of bars and clubs with names like Wahoo and Woo Woo. In this photograph there are only three architectural reminders of the 1880s. St Paul's Church survived the razing of the whole west side and its conversion into Churchill Square. Nowadays, it calls itself a 'jewel

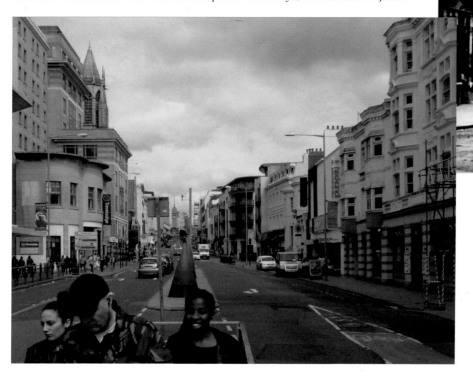

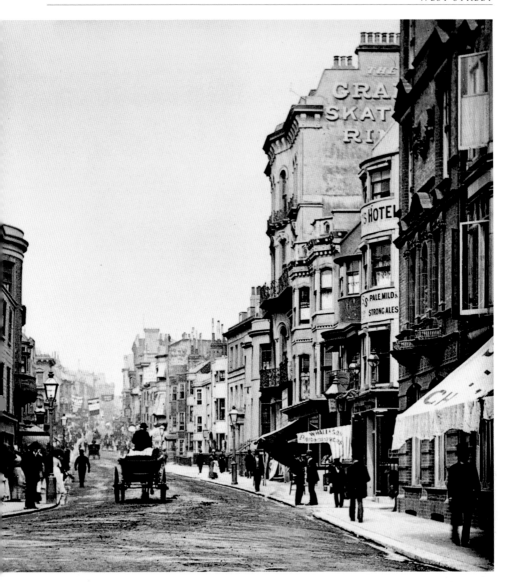

of the Anglo Catholic movement'. Secondly, on the east side, there is the three-storey part of the Victorian mansion block which once abutted the old skating rink, while the four-storey part that corners onto King's Road was constructed later. No.77 West Street, with two wide curved bows (just visible in the old photograph), dates from the early nineteenth century, and served the local gas company for the first half of the twentieth century; but, since then, it has been a restaurant, and is currently a bar called Kulture. The old skating rink/dance hall has a modern façade, and is now another bar called Hed Kandi. The cones, in the middle of the street, light up at night. They were designed by Raphael Daden and were installed in 2001 as part of a £25,000 council art project.

ROYAL PAVILION

THE EXTRAORDINARY AND unique Royal Pavilion has been Brighton's most picturesque and memorable sight for the best part of two centuries. The Prince of Wales, later King George IV, wanting a place to stay in Brighton, took over a farmhouse in the 1780s and commissioned Henry Holland to convert it to a royal residence. By the time George was made Prince Regent, it had become the grand Marine Pavilion, but, by then, it was no longer grand enough. He turned to John Nash – responsible for the look of Regent's Street, Regent's Park and later for the remodelling of Buckingham Palace – to transform it into a palace. In doing so,

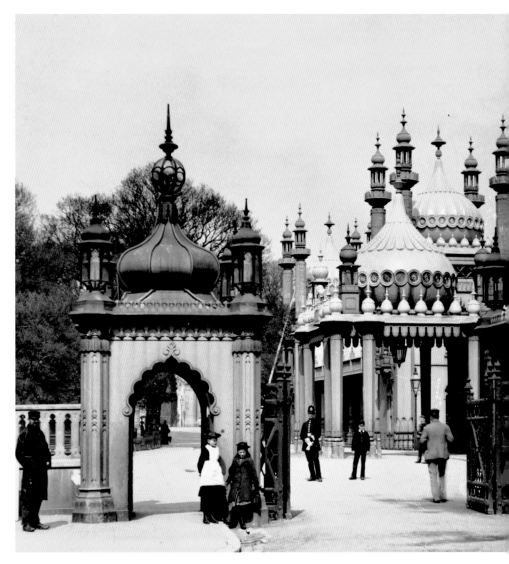

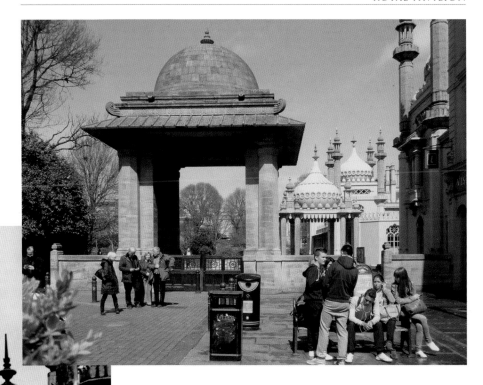

Nash borrowed from Mughal architecture, spent a vast amount of money, and created the spectacular oriental palace visible today. George IV's brother and successor, William IV, stayed at the palace often, but his successor, Queen Victoria, had no time for Brighton, so the buildings were sold to the town in 1850. Within a year, it had been opened to the public. This photograph of the Pavilion, through the south gates, was taken at the turn of the century.

DURING THE FIRST World War, the Royal Pavilion estate was used as a military hospital, initially for members of the Indian Corps wounded on the Western Front, and later for 'limbless men'. During the early period, the building and its Indian patients were extensively photographed. The images became a tool for showing the benevolence of the British Empire to its colonial troops, and, incidentally, gave the Royal Pavilion an international presence it had not enjoyed since the Regency period. The South Gate visible in this contemporary view – the only significant difference from the old photograph – was gifted in 1921 by India in commemoration, a plaque says, of 'her sons who, stricken in the Great War, were tended in the Pavilion'. Today, the Pavilion, with its flamboyant Chinese-inspired interior and on-going programme of exhibitions, attracts hundreds of thousands of visitors a year.

THE DOME

THIS EARLY PHOTOGRAPH of the Dome (1866) was taken just before it reopened as a great concert hall with a gas chandelier and room for over 2,000 people. Originally, in the early 1800s, it had been built as a stable for the Prince of Wales by William Porden, and boasted a dome 80ft in diameter and 67ft high. It could accommodate nearly fifty horses and their handlers. On the western side, Porden's design also included a riding school. The buildings were purchased by the town with the Pavilion estate in 1850, and were then let as cavalry barracks for ten years or so from the mid-1850s to the mid-1860s. It was from about the time of the concert hall reconstruction, to a Moorish design by a borough surveyor, Philip Lockwood, that the building was called The Dome. The riding school, however, acquired its current name – the Corn Exchange – when it was appointed to house the town's Thursday corn market in 1868.

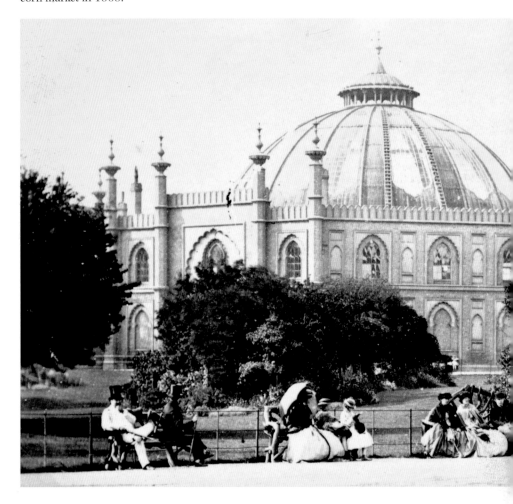

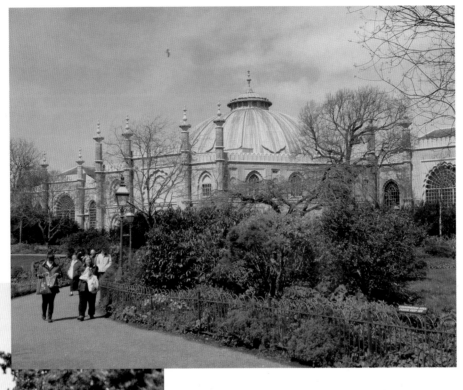

THE DOME AND Corn Exchange retained their functions until the First World War when, like the rest of the Pavilion estate, they housed wounded soldiers. The Dome was given a complete redesign in the 1930s, an electric organ, and new balcony, and then served as the town's principal entertainment venue for forty-odd years. After the war, the Corn Exchange was converted into a function room, and, in the 1930s, a so-called supper room was added on the New Road side. In 1974, the Dome hosted the Eurovision Song Contest won by Abba with 'Waterloo'. The buildings today, as seen in this photograph across Pavilion Gardens, house three entertainment venues – the Dome, the Corn Exchange and Pavilion Theatre – all of which have diverse programmes throughout the year, and are particularly busy during the Brighton Festival. They also house, on the right in the above photograph, Brighton's prestigious museum which claims to have 'one of the most important and eclectic collections outside national institutions'.

NEW ROAD

BY THE TIME of this 1895 photograph New Road was around ninety years old already. It was built to provide an alternative thoroughfare when the Prince of Wales was allowed to close off a route past his Marine Pavilion. The attractive colonnade, once known as the Royal Colonnade, originally fronted the Royal Theatre, halfway down New Road, but was extended to, and round the corner into, North Street during the 1820s. Theatre Royal, the building with a turret just visible at the colonnade's end, already had a distinguished history by this time. Given royal approval, the theatre was built in under a year and opened in 1807 with Charles Kemble playing in *Hamlet*. Two major structural changes followed in the nineteenth century,

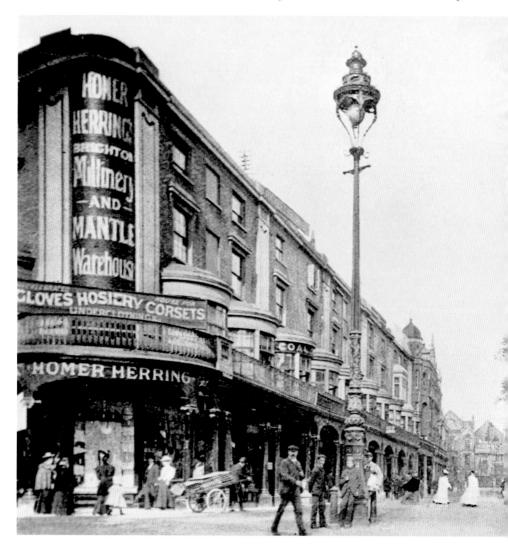

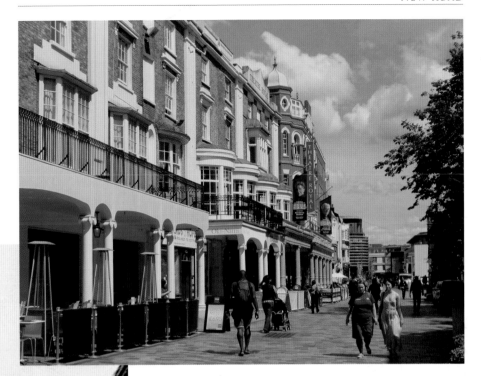

one of the interior in the mid-1860s by Charles Phipps, and another of the exterior by C.E. Clayton not long before this photograph was taken. By the time of the latter rebuild, which introduced the red-brick and terracotta frontage, and the turrets, the theatre had also absorbed adjacent buildings.

THIS IS NEW Road today, not long after an award-winning project remodelled it as 'a shared space'. According to the Civic Trust Awards scheme such areas give pedestrians priority and allow 'a café culture' to evolve. Much of New Road's colonnade was lost in the early part of the twentieth century, for one reason or another, and only a small part remains on the building adjacent to the Theatre Royal. The theatre itself retains its late nineteenth-century look, and, despite some ups and downs, has long been considered one of the country's best provincial theatres, often opening productions en route to the West End. In celebration of its 200th anniversary, in 2007, the theatre was visited by the Queen and a box was named in her honour. Beyond the theatre, and across Church Street, the glass-fronted Jubilee Library is visible. Until this ultra-modern and innovative building opened in 2005, the library had been housed in the old Dome buildings beside the museum.

NORTH LAINE

THE AREA KNOWN today as North Laine (often mistakenly called the North Lanes) is contained within a block of land bounded by North Street to the south, Trafalgar Street to the north, Queen's Road to the west, and the traffic-filled Marlborough and Gloucester Places to the east. Prior to the nineteenth century, this was agricultural land, a 'laine' – i.e. a large common field, one of several at the base of the Downs around Brighton, leased out to tenants in small plots. Development began during the first half of the eighteenth century, and continued through the railway boom era of expansion in the 1850s and 1860s. The character of the area evolved, in particular, from the way the small plots were developed piecemeal for low-cost terraced housing. The photograph shows the Co-operative Clothing Stores at the corner of Sydney Street and Trafalgar Street around the turn of the century.

THE QUIRKY, INDEPENDENT shops in the North Laine quarter – mostly in a line along Sydney Street, Kensington Gardens and Gardner Street – provide a welcome change from the commercial bustle of Brighton in The Lanes and Churchill Square. Here

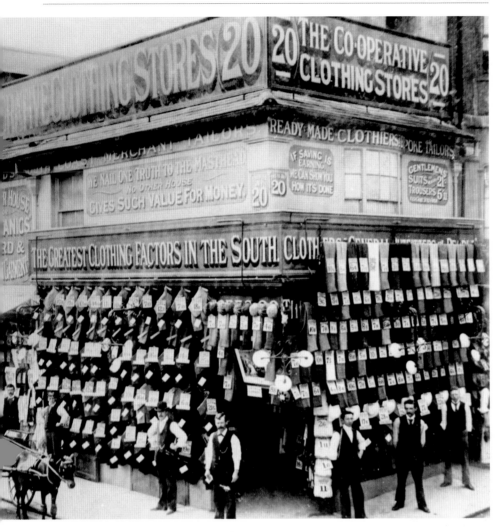

can be found vintage and fancy dress, original design clothing, new-age paraphernalia, green merchandise, mod gimmicks, kites, toys, foodstuffs, and cafés. The building that once housed the Co-operative Clothing Stores is now home to Sydney Street Bikes, one of Brighton's many cycle shops. Other outlets on Sydney Street, just out of view, include Revamp Fancy Dress, Cyberdog, Books for Amnesty, Natural Flooring Centre, Bead Shop, Yum-Yum Oriental Market, Penetration, Hope & Harlequin. Komedia, a lively cinema, comedy and music centre, sits in the centre of North Laine along Gardner Street. On the day of this photograph, 5 May 2012, Sydney Street and many other roads were closed for the Children's Parade which starts the Brighton Festival every year. Boys, girls, parents and teachers from nearly 100 schools come together for a most colourful and thrilling procession of floats and bands that weave their way from North Laine to Madeira Drive.

NORTH ROAD

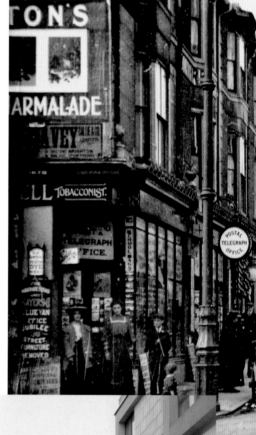

NOT TO BE confused with North Street, North Road was originally developed in the 1810s and 1820s along a narrow lane, but was then widened in 1870. By 1904 (a few years before this photograph), the town had a sizeable tram system, with routes spreading out from Old Steine as far as Seven Dials, Fiveways and Race Hill. This line along North Road only served trams going up to Queen's Road and the station. To the left of this view, on the corner with Jubilee Street, is a tobacconist and telegraph office. The next shop along was a boot maker, and the next a chemist. Opposite, in the block nearest the foreground, was a bookbinder, draper, eating

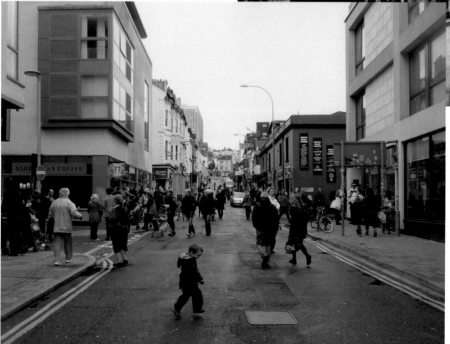

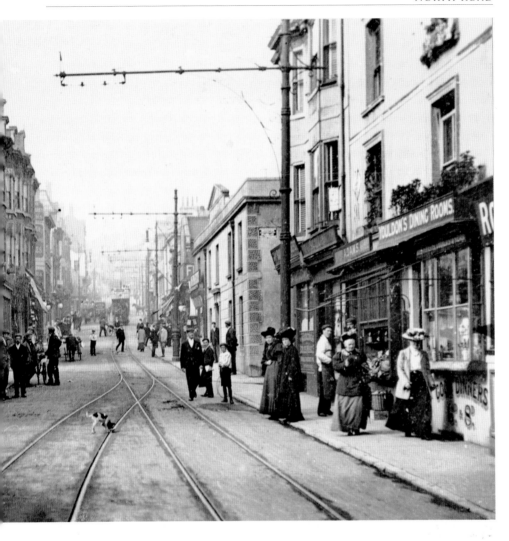

house and a printing works. The next block, with the flat-topped building, was a grocer's. There were also a dozen or more pubs along North Road at the time.

NORTH ROAD IS recognisably the same today, a century on from the old photograph, even though blocks of terraced shops on both sides have been demolished and replaced by new structures. The flat-topped grey building now sells timber. Opposite is Infinity, a workers' co-operative offering an extensive range of vegetarian foods. Roads leading off to the left are Jubilee Street, in front of Starbucks, which leads to the Jubilee Library, and Gardner Street. On the right are Kensington Street and Kensington Gardens, where the first branch of Anita Roddick's Body Shop opened in 1976. Today, there are half as many pubs on North Road as there were 100 years ago; but then there were no tattoo/piercing parlours and there are three now.

MARLBOROUGH PLACE

MARLBOROUGH PLACE DATES back to the 1770s, when the first buildings, known as North Row, became the first development outside the old town. These houses – once an excellent example of the pebble-front construction still found around Brighton – are said to have been built to accommodate the servants of William IV, but were pulled down shortly after this photograph was taken in the 1930s. The large notice states that a new office is to be built for Citizen's Permanent Building Society.

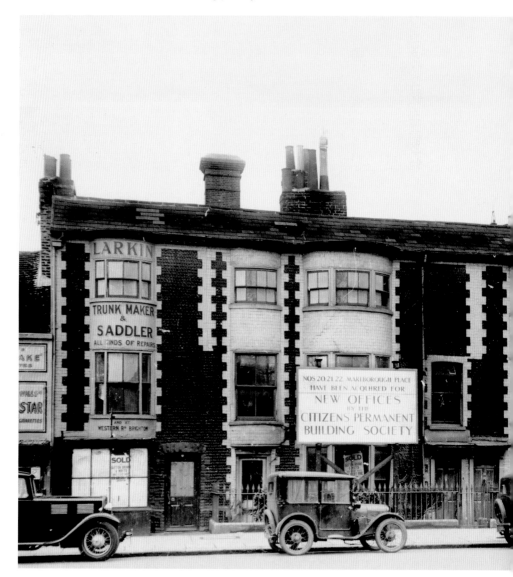

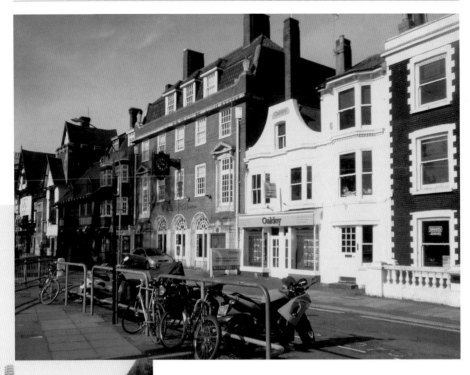

THE ALLIED IRISH Bank property, seen in the middle of this disparate row of buildings, is the one which replaced the pebble-fronted terrace. Designed by John Leopold Denman in Neo-Georgian style, it served the Citizen's Permanent Building Society until the 1980s when Allied Irish took it over. Further along is the large and flamboyant King and Queen pub, beloved of Brighton's many students. It was designed by Clayton & Black, a local firm, in mock Tudor style, and built a year or so before its far more sober building society neighbour. A pub named the King and Queen (after King George III and Queen Charlotte) dates back to 1779 when a farmhouse on North Row was re-fronted in Georgian style. In its early days, it was said to profit from an illicit trade, through a secret hatch, with soldiers housed in barracks at the back. Between the 1820s and 1860s, the town's corn market was held here, until it moved into the former riding school in the Dome buildings. Nearer the foreground are several buildings that were not demolished in the 1930s, including No. 26, on the corner with Church Street, which shows its original pebble-front construction.

BRIGHTON STATION

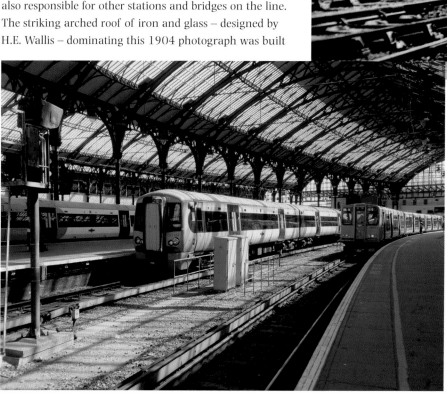

BRIGHTON STATION OPENED in 1841 after more than fifteen years of planning, discussion and complicated construction. Initially, many townsfolk were against the idea, but then compromised, agreeing to a rail link with Shoreham. The government, however, decided on a direct line from London. A plan to situate the terminus on Hanover Cricket Ground (now Park Crescent) was superseded by one to place it above North Laine. The project required much excavation and cutting into the chalk hillside. The station and line were built and operated by London & Brighton Railway Co. (though, within a few years, it had been amalgamated into a larger company). The terminus building itself was designed by David Mocatta, who was also responsible for other stations and bridges on the line. The striking arched roof of iron and glass – designed by H.E. Wallis – dominating this 1904 photograph was built

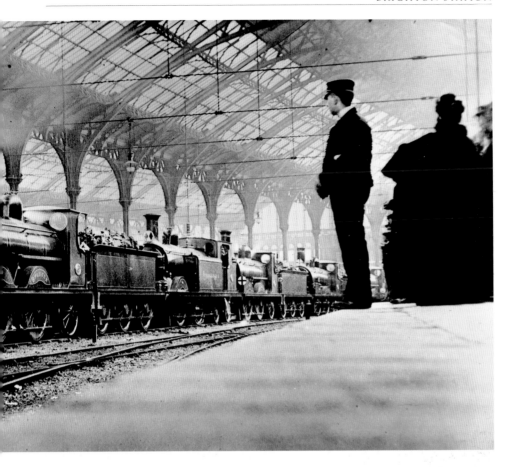

in the 1880s, by which time the station had outgrown its original design. According to James Gray these are excursion locomotives in the station, awaiting a signal to enter the locomotive yard; and at their head is the D2 class locomotive 309, very near the end of its life.

THOUGH BRIGHTON ITSELF has undergone many major changes in the last 100 years or so, the station interior has seen relatively little alteration. It also survived a 1970s plan by British Rail to rebuild the complex entirely, thanks largely to vigorous public opposition. The rolling stock, however, has undergone radical change. The old steam engines were finally withdrawn in the 1930s after electrification of the line. The *Brighton Belle*, a luxury Pullman and one of the most famous trains ever to do the London-Brighton run regularly, had been steam-hauled until this point. With electric engines, though, it became the first all-electric all-Pullman service in the world. It ran until the 1970s; and, famously, Laurence Olivier, while living in Royal Crescent, supported another public protest, this time against withdrawal of kippers from the *Brighton Belle* menu. Nowadays, the station is a busy terminus – servicing around 15 million passengers a year – mostly for Southern Railway trains in their green and yellow livery.

BRIGHTON BUSES

THE AREA IN front of Brighton station has changed more over the years than the interior. Up until the time of this 1920s photograph, buildings still existed all along Surrey Street right up to the station, allowing no traffic access to Queen's Road. Those behind the bus in the photograph – which included the Flowing Stream pub – were soon demolished to give easier access for buses. Even more houses were taken down in the 1930s to open up the space for bus bays. The No. 6 bus ran from Brighton station to Portslade, and was operated by Tilling, part of a nationwide group. By 1916, Tilling had replaced all the horse-drawn buses in the town with motorised transport (though Brighton Corporation managed the tram system). Tilling continued to operate Brighton's buses until they were nationalised in 1948.

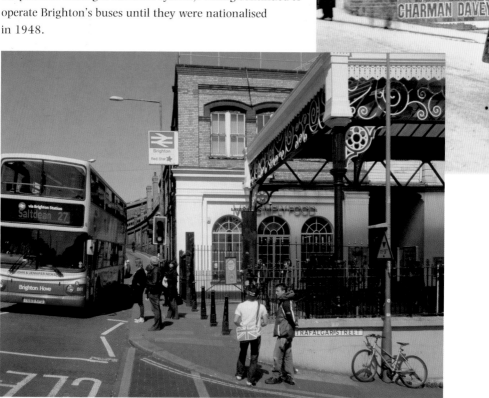

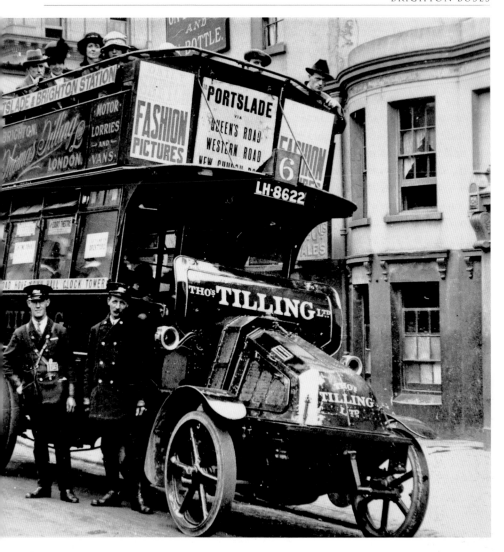

THE STATION'S 1880s canopy – visible in both photographs but often criticised for masking Mocatta's station front – was given a fresh coat of paint in 2011. It continues to sport the dark blue colour, Southern Railways says, in keeping with the station's heritage. Trafalgar Street to the right leads down to North Laine, while Terminus Street curves along the line of the station architecture towards Seven Dials. The double-decker bus, No. 27, seen in this photograph travels from Westdene, past the station and along the seafront to Rottingdean and Saltdean. It is one of nearly 300 buses managed by Brighton & Hove Bus and Coach Co. (part of the Go-Ahead Group since 1993). The company says all its buses are state-of-the-art, and run on biodiesel. Many of them are named after famous people with some kind of connection to the city. This one is called 'John and Jennifer Nicks', a brother and sister who became famous ice skaters after the Second World War, and won a gold medal at the 1953 World Figure Skating Championships in Davos.

TRAIN YARDS

NEARLY FIFTY ENGINES, all coaled up and ready to steam, can be seen in this 1903 photograph taken from Buckingham Place. The large space was created in the 1860s by the London, Brighton and South Coast Railway Co. allowing it to use what had been the depot area to expand its locomotive works (on the right of the photograph). Very approximately in the century between the 1850s and 1950s, this yard constructed over 1,000 steam locomotives as well as prototype diesel electric and electric locomotives,

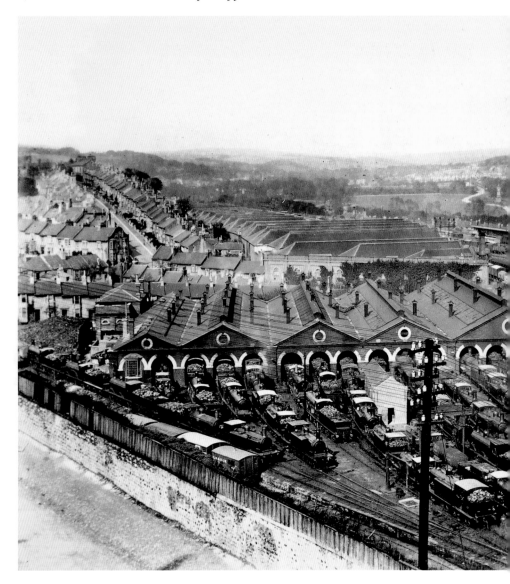

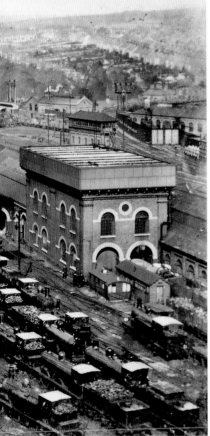

before closure in 1962. On the left of the photograph can be seen Hamilton Road, rising steeply. It was built in the 1860s, part of the development of Preston parish. Eric Gill, the sculptor, printmaker and engraver who later lived in Ditchling, was born at No. 62.

TODAY, THE OLD steam engine depot has been replaced by large warehouse-type buildings, holding offices and sundry facilities for various train companies. The track in the foreground goes to Hove station and along the South Coast to Portsmouth. The track that runs to the east of the warehouses (and Southern Railway depot buildings with white roofs) is the main line to London. To the east of that can be seen the trees of Preston Park, and beyond is Preston Drove that leads up past a large area of terraced housing to Fiveways. The South Downs can be glimpsed in the distance. Hamilton Road looks largely unchanged, apart from the line of parked cars. The area to the right of this photograph, and out of view, where the locomotive works used to be, is now dominated by the recently developed New England quarter, with a modern hotel, language school, and blocks of flats.

QUEEN'S ROAD

QUEEN'S ROAD WAS built a few years after Brighton station was opened so as to provide easier access to North and West Streets. Slum areas off North Street were cleared for the project, as was the western side of a burial ground serving Hanover Chapel. This sedate view, with the station in the distance, was photographed in 1911 from the corner of Church Street. The new railing on the right provides a boundary with the rest of the cemetery, while the old railing and wall can be seen on the left as an edge to the raised pavement. Next to the Gent's Hair Cutting Rooms (run at the time by George Batty) were a coal merchant and a musical instruments depot. Beyond that, the 1830s building was probably designed by Wilds and Busby. By 1911, it was home to the Sussex Masonic Club.

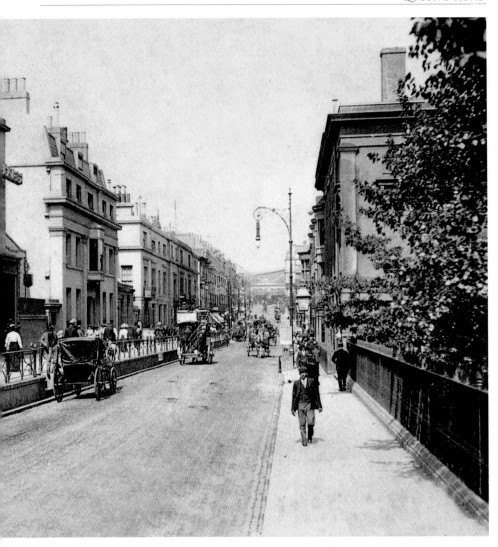

TWO BRIGHTON TAXIS head south on this stretch of Queen's Road, now restricted to buses, taxis and cycles, towards the clock tower and North Street. On the right is the garden of Brighthelm Church and Community Centre. The original Hanover Chapel was employed by the Presbyterian Church from 1844 to the 1970s and is now part of the United Reformed Church. After a fire, the Hanover Chapel was rebuilt, in the late 1980s, and a community centre added to one side. The church and centre are together called Brighthelm, and some of the perimeter walls of the garden are lined with the old gravestones. Across the road is Fair, claiming to be Brighton's premier ethical fashion boutique, a recruitment office, and Headcase Barbershop. The Wilds and Busby building was substantially extended by John Leopold Denman (who was also responsible for the neo-Georgian architecture on Marlborough Place) in the 1920s with a Masonic temple to one side.

ST NICHOLAS' CHURCH

ST NICHOLAS', THE original parish church of Brighton, and also considered to be the city's oldest surviving building, was constructed in the fourteenth century, possibly on the site of a far older church, as mentioned in the Domesday Book. However, much of what can be seen in this photograph (taken around 1870) and indeed today, stems from a major rebuilding in the 1850s, zealously carried out by Richard Cromwell Carpenter, so that, externally, only the tower now dates back to the original church. Inside, the oldest surviving relic is a Norman font, of Caen stone, thought to have been carved in 1170. The rood screen is also old, carved in oak as early as 1480.

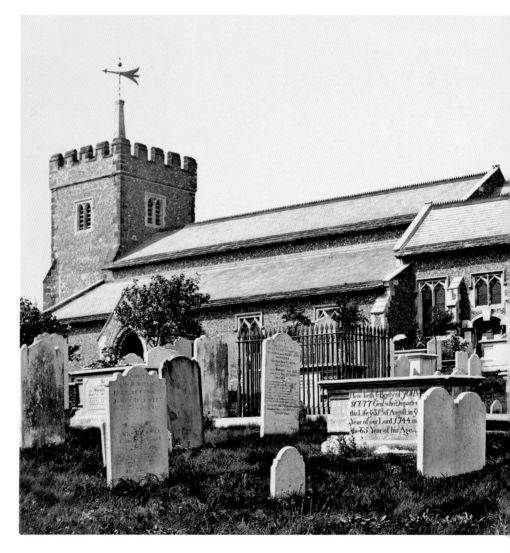

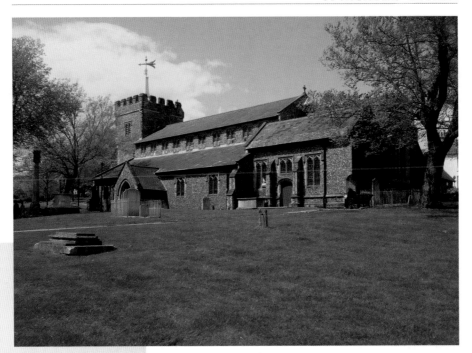

IN THE 150 or so years between the two photographs, there have been many more changes to the church – repairs, alterations, extensions – but the only one that altered the external look significantly took place in the early 1890s. Then, the whole roof was lifted mechanically so as to let in more light through a series of so-called clerestory windows. The stained glass and various paintings and murals inside were created by Charles Eamer Kempe (a cousin of the Thomas Kemp who developed Kemp Town). The old churchyard, which had not accepted new burials for a century or more, was landscaped by the council in the twentieth century. Most of the gravestones were moved, but a few interesting ones remain. On the right of the photograph, by the bench, is that of Stephen Gunn and his more famous wife Martha. Known as Queen of the Dippers, Martha helped fashionable ladies manoeuvre into and out of their bathing machines (some of these can be seen on the beach in the Volk's Railway photograph). She was also a favourite of the Prince of Wales. Another gravestone, to the left and also surrounded by railings, is that of Phoebe Hessel (1713–1821) who pretended to be a man in order to serve as a soldier and be with her lover.

CLIFTON HILL

THIS IS UPPER North Street in 1870, a short distance west of St Nicholas' church, and looking west. It runs across the southern edge of Clifton Hill, which includes the Montpelier area, and was developed with largely high-class housing from the 1820s. The area is now considered to have many fine examples of Regency and Victorian architecture. The tall-spired Catholic church, St Mary Magdalen's, was erected in the early 1860s to a design by Gilbert Blount, who had started his career as civil engineer under Isambard Kingdom Brunel. At the time, Brighton had only one other Catholic church, in Kemp Town. A primary school, also named St Mary Magdalen, stood on the west side, and a presbytery was built later in 1890. On the far side of the church is the Hampton Arms; and behind where this photograph was taken was another pub, the Windmill, dating to the 1820s, which probably took its name from William Vine's post mill that stood nearby until about 1850.

ST MARY MAGDALEN'S is now one of nearly a dozen Roman Catholic churches in Brighton & Hove Council area. Not much has changed in the century and a half, though the organ was replaced in the 1960s, and two statues carved by Joseph Cribb, a pupil of Eric Gill, were installed above the entrance. The old school is now a community centre. In 2006, Pope Benedict XVI awarded Hugh Gerard McGrellis the Benemerenti Medal for a

lifetime of service to the Church, most notably as an altar server for over seventy years. (This was the only Benemerenti Medal awarded by the Pope that year.) Both the Windmill and the Hampton Arms are still going strong. The area that includes Upper North Street was designated as the Montpelier & Clifton Hill Conservation Area in 1973, and extended in 1977. In 2005, local residents formed the Clifton Montpelier Powis Community Alliance, 'to foster a sense of community and help residents come together to discuss and take action on issues of concern in the area'.

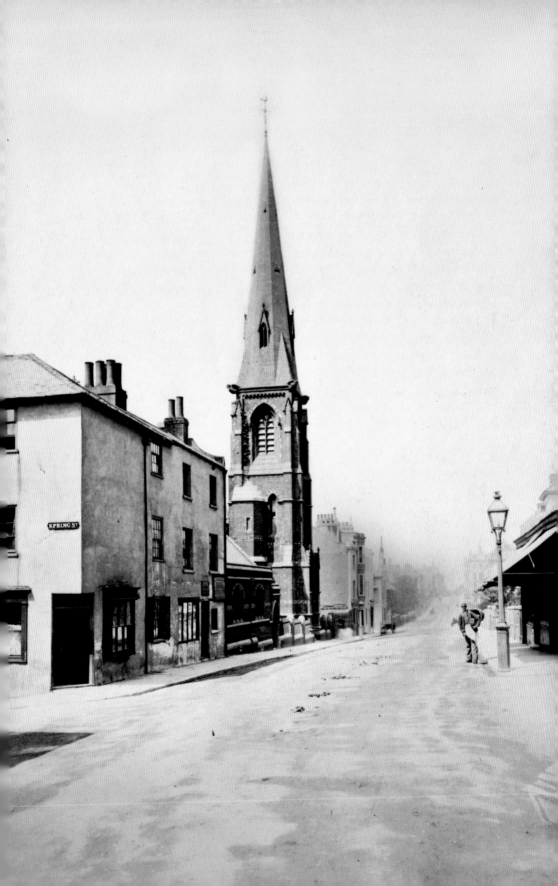

SEVEN
DIALS

THE SEVEN DIALS junction of seven
roads is situated north-west of the
station, and little under a mile from
the seafront. It is said to have taken its
name from a similar junction in Covent
Garden, London. This photograph, taken
in about 1912, looks south along Dyke
Road. At the time, on the left-hand side
were a grocer's, a fish and poultry store,
a bookseller, a chemist and a dairyman.
An auctioneer and estate agent named
Reason, Hobbs and Tickle was situated
on the other side of the road. By 1917, it
had lost Hobbs, but otherwise continued
trading until the 1930s. For centuries,
Dyke Road, which continues in the other
direction north, was the main route into

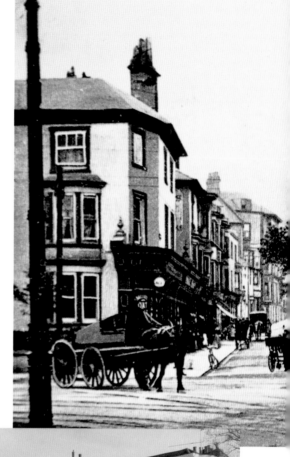

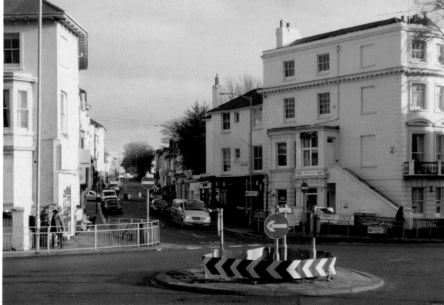

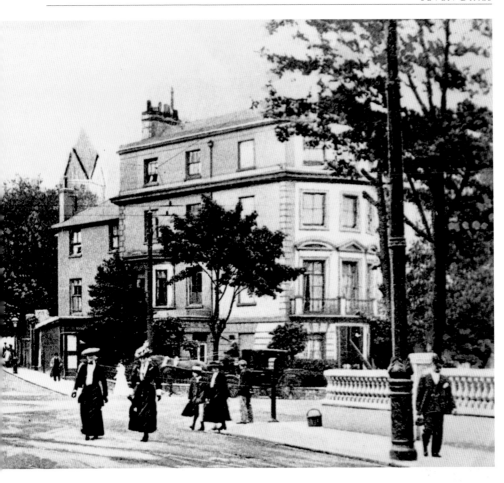

and out of Brighton. A little way north was No. 38, where Magnus Volk was living; and further along was the Booth Museum, built in 1876 to house Thomas Booth's remarkable collection of stuffed British birds.

THE BUSY, TRAFFIC-DENSE and ugly Seven Dials of today stands just beyond the far northern corner of the Montpelier & Clifton Hill Conservation Area. To the left of this photograph are Chatham Place, which leads down underneath the railway bridges to Preston Circus, and Buckingham Place, which curls down to Terminus Road and the station. To the right are Goldsmid Road, going towards Hove station, and Vernon Terrace, which leads to Montpelier Crescent, designed by Amon Henry Wilds, one of the delights of the Conservation Area. To the north, are Dyke Road, along which one can still find the museum full of Booth's stuffed birds, and the smaller Prestonville Road leading to Hamilton Road and the Port Hall area. The junction serves as a secondary shopping area with small food stores, pubs and cafés spread along several of the roads. Among the businesses on the left-hand side in this photograph are a Co-operative Food store, Tinkers Hardware, Tutti Frutti and Moorish Brighton.

71

WESTERN ROAD, BRIGHTON

THIS PHOTOGRAPH SHOWS Boots on Western Road having a sale – 'Bargains to suit everyone'. The company was started in the mid-nineteenth century by John Boot, an agricultural worker, on moving to Nottingham. After his death, his wife and his son, Jesse, developed the business. They went from having only ten stores in 1890, to over 550 by the start of the First World War. With the war over, Jesse sold Boots to the United Drug Company of America, and thus it was under US ownership when the building in this photograph, taken in late 1926, was to be completely rebuilt. For centuries Western Road had been but a narrow track from North Street running through farmland, and it was only with development in the late eighteenth and early nineteenth centuries that it

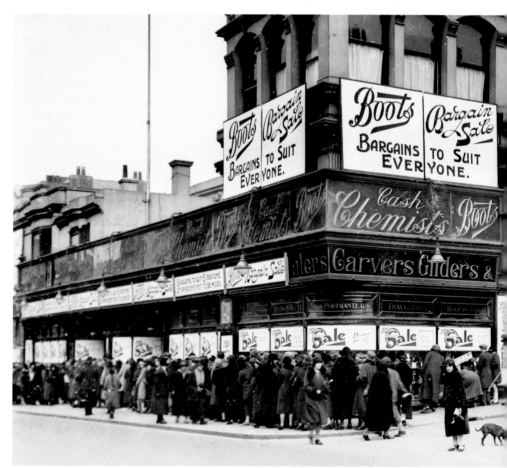

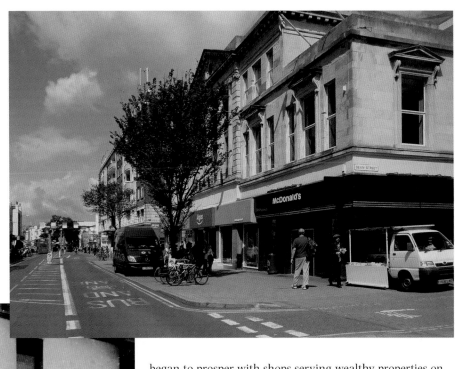

began to prosper with shops serving wealthy properties on the south side towards the sea, and on the north towards Clifton Hill. By the 1920s, the street was deemed too narrow, and the authorities began enacting a widening plan. James Gray attached the following 1927 newspaper cutting to this photograph: 'The holding of Empire Shopping Week seems an appropriate time to draw attention to progress being made with the widening of Western Road and the clearance which is taking place in readiness for the erection of the new premises of Messrs. Boots. The clearance is one of the biggest Brighton has ever known, and the speed with which it has been effected has caused astonishment.'

THE GRAND EDIFICE built for Boots between Dean Street and Spring Street in the late 1920s today looks old, neglected and almost preposterous above the Argos and McDonald's street façades. By 1933, Boots had opened its 1,000th shop, but that same year the company was sold back to a group of financiers led by John Book, Jesse's son. Present day Western Road – probably Brighton's principle shopping street for over a century – is a jumble of buildings, big and small, old and new, rarely showing any attractive features.

WESTERN ROAD, HOVE

THIS IS THE start of Western Road, Hove, an extension of Western Road, Brighton. The boundary line between the two parishes ran, more or less, across the foreground of the photograph. Jenner & Parker, an estate agent, occupied No. 1 Western Road, Hove, on the corner with Little Western Street, for about fifteen years from 1896. Before then, the site had been occupied by the Little Western Tavern and by a pastry cook. Next door to Jenner & Parker were a dressmaker, a hairdresser, a grocer, a wine merchant, a shirt maker, and then a cycle shop. Two blocks down can be seen the cupola on the four-storey Western Tavern which, by the time of this photograph, was already at least half a century old.

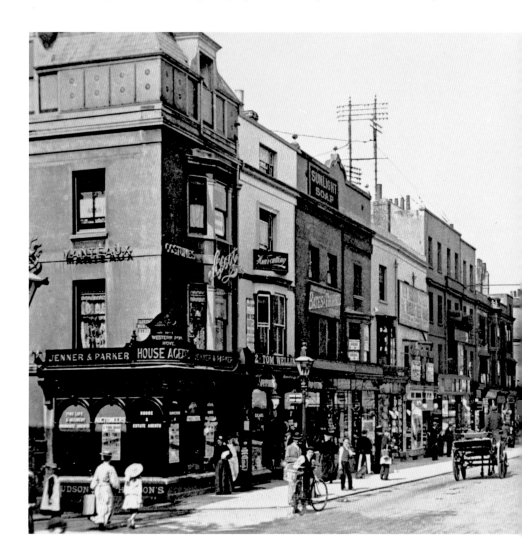

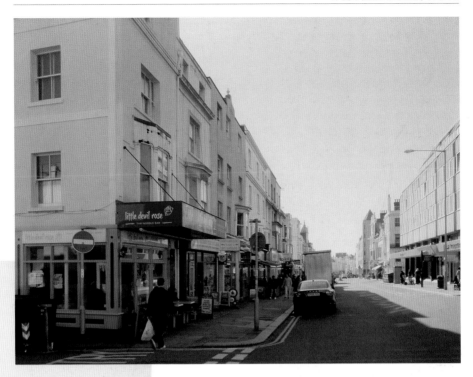

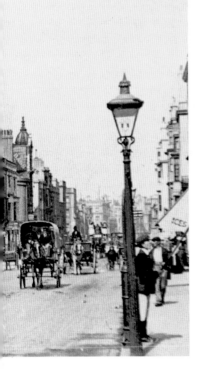

ADMINISTRATIVELY, BRIGHTON AND HOVE were unified in 1997, and then granted city status by Queen Elizabeth II as part of the millennium celebrations in 2000. The switch from Western Road, Brighton, to Western Road, Hove, thus has become far less meaningful. There is still, though, an alley called Boundary Passage on the north side, and a boundary stone (embedded in the pavement) marking the old division. Unlike those along the Brighton part of Western Road, these buildings look virtually unaltered from how they were a century ago. Their uses at street level, however, have undergone many and varied changes. By the 1950s, the cycle shop in this first block on Western Road, Hove, had expanded, the shirt maker had become a butcher, and the grocer's store had been taken over by Sainsbury's. Most interestingly, perhaps, from about 1912, the first building, No. 1, housed – to the rear – the Hove Cinematograph Theatre. From 1922, it was called Tivoli Cinema, and then, from 1948 to its closure in 1981, it was the Embassy Cinema. Thereafter, for a while, it served as a pine furniture store, before a plan to launch a lap-dancing club was refused planning consent. The auditorium at the rear was eventually pulled down in favour of new housing.

PRESTON CIRCUS

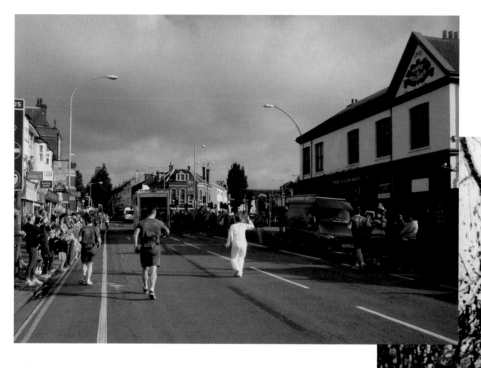

DATING FROM 1898, this charming wintry view looks on to Preston Circus from London Road. On the right is the Hare & Hounds, built half a century earlier (but which was about to be demolished and rebuilt a few years later). The imposing looking building jutting out into Preston Circus had been the Amber Ale Brewery, constructed in around 1880 by Henry Longhurst, but was now managed by R. Fry & Co., manufacturers of mineral water. Longhurst had started brewing his Amber Ale in the 1850s, probably on the site where the Stanford Arms (by the lamp post in the photograph) was built in the same period as the new brewery. Longhurst, himself, lived in a house on London Road opposite the Hare & Hounds.

PRESTON CIRCUS HAS changed very much over the last century, and these days is usually a nightmare of vehicles. However, on the morning this photograph was taken (17 July 2012), the road was closed to traffic for the Olympic Torch Relay. By the early 1920s, already, the junction was controlled by a policeman; by the end of the decade, semaphore signals had been erected, also controlled by a policeman; and, in the early 1930s, traffic lights arrived. Only the Stanford Arms, now called

Circus Circus, is recognisably the same. The Hare & Hounds has retained neither its name – it is now called The Hydrant – nor its architecture. And, most noticeably, the old brewery building has gone. This was demolished, soon after the old photograph was taken, to allow tramlines to be built round from Viaduct Road into Beaconsfield Road. Subsequently, part of the old premises was adapted for use as a fire station while the old maltings were transformed into the Duke of York's Picture House (both just out of view). The fire station was enlarged in the 1930s, with several large fire engine doors leading directly into the Preston Circus junction. In 2010, Duke of York's, which claims to be the oldest continuously operating purpose-built cinema in Britain, celebrated its centenary.

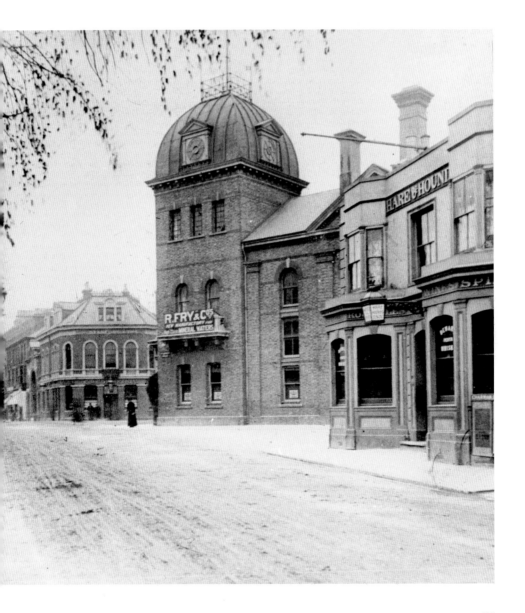

PRESTON ROAD

THIS PHOTOGRAPH WAS taken half a block or so north of Preston Circus in the 1890s, and looks further north towards Preston Park. The impressive London Road viaduct is almost certainly the oldest edifice in the photograph. It was built in 1845–1846 to a design by John Urpeth Rastrick to serve trains going east, from Brighton station to Lewes and Hastings. The long curving structure, Grade II* listed, has twenty-seven arches and is said to consist of 10 million bricks. At the time, the viaduct crossed a valley of fields, owned by William Stanford. In 1804, Stanford had rented some of the land (near what would become Preston Circus) to the Prince Regent who wished to run a dairy farm.

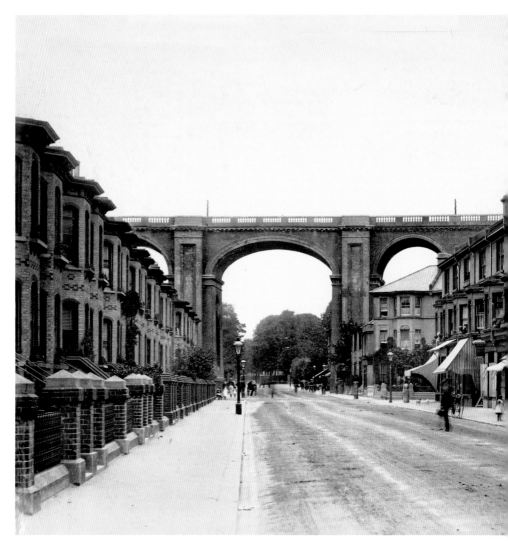

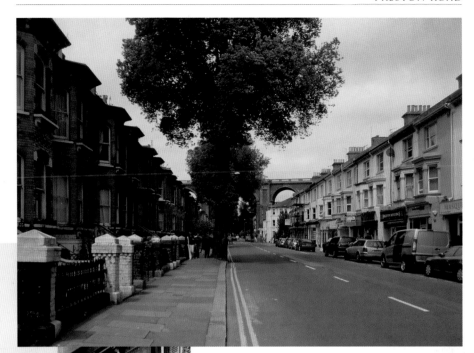

The houses on the west side of Preston Road, seen here, were developed from the so-called Dairy Estate. Initially constructed in the 1870s and called Rosneath Terrace, it soon became Preston Road. Near the viaduct, there were a coffee roaster, a Wesleyan Iron Church, the Brighton Bicycle Co., and Preston Road School. A few years earlier, during building work on the east side of the road near the viaduct, an archaeological site was discovered, possibly a Roman villa or temple and cemetery.

PRESTON ROAD TODAY is a busy one-way route for traffic leaving Brighton. The old yellow- and red-brick Rosneath Terrace remains attractive and largely residential. The east side, though, is mostly shops with some student flats above. The businesses are a curious mix of traditional and trendy. The traditional include trade stores such as Cannadines selling plumbing equipment, and Aird & Co. selling tools; while the trendy include Masquerade which takes care of Sussex party-goers 'costume dreams' and EatonNott selling 'roadkill couture'.

PRESTON PARK

IN 1883, BRIGHTON Corporation purchased 67 acres of
meadow land from the owner of the Preston Manor estate,
who had already begun to develop the land as a park. The cost
of £50,000 was taken from a bequest made to the town by a
bookmaker, William Davies. About half the amount again was
spent on landscaping, and Preston Park was formally opened
in 1884. Three years later, the chalet café, seen in the middle
of this 1897 photograph, was opened; and, a few years after
that, in 1892, the handsome red-brick and terracotta clock
tower (behind and to the right of the café) was inaugurated.
Out of view, in the far left corner, a cricket ground had been
opened in 1887, taking over an area hitherto serving as the
International Gun Polo Grounds. Polo continued to be played
in the main park itself; there were also tennis courts and
bowling greens. In the distance, beyond the park, several roads
– Preston Park Avenue, Beaconsfield Villas, Havelock Road
and Waldegrave Road – can all be seen, only half-developed.

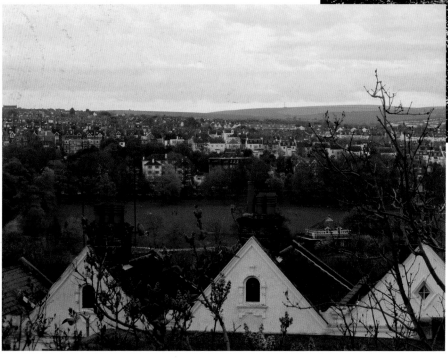

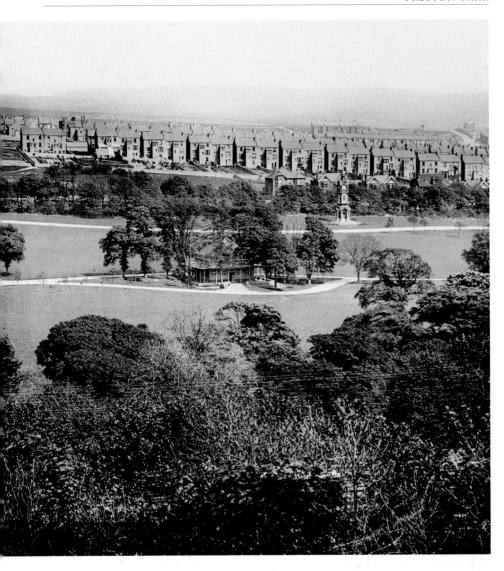

A SIMILAR OPEN view of Preston Park nowadays and from the same point is difficult to find, such is the density of housing. This view is from Inwood Crescent, very near where the older photograph was also taken. Both Inwood Crescent and Miller's Road below it (along which are set the houses visible in this contemporary photograph) were not built until the early years of the twentieth century. As for the park, it was redesigned in the 1930s by the Parks Superintendent, Captain MacLaren, with new bowling greens, pavilions, a fountain, a pond and the Rotunda café (acquired from the 1924 British Empire Exhibition at Wembley). However, his plan for a boating lake and waterside bandstand were rejected. The park is little changed from the 1930s remodelling, but does now have a large children's playground, basketball courts and football pitches. Polo is no longer played.

ST JAMES'S STREET

DEVELOPMENT ALONG ST JAMES'S Street, going east from the Old Steine, started as early as the late eighteenth century, to serve the East Cliff area. Some of the buildings in this early 1920s photograph (looking back towards the Steine) were built a century earlier than that. No. 9, for example, a little beyond the tobacconist on the right, had been built in the 1820s to a design, with fluted Ionic columns, by Wilds and Busby. For some years, in the 1820s and 1830s, before moving to the Royal Albion Hotel, the Brighton General Library, Literary and Scientific Institution met there. A Liptons Tea merchant was trading at No. 9 at the time of the photograph, and next door to it was No. 7, the Argentine Meat Co. On the other side of the road, starting near the foreground, were a bookseller and draper, another tobacconist, a watchmaker, a builder, and a Doll's Hospital.

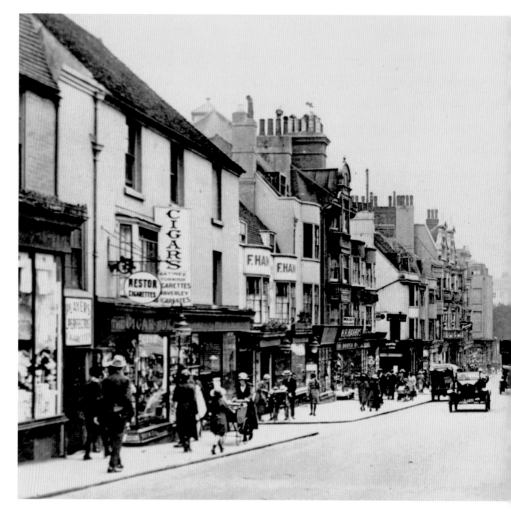

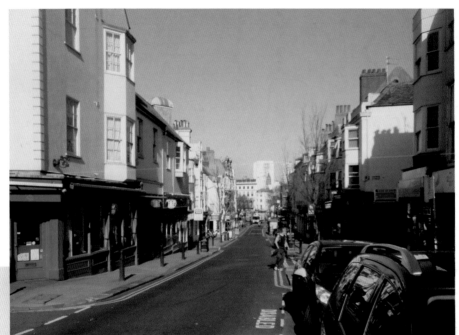

A CONTEMPORARY VIEW of St James's Street – which leads up to the fashionable Kemp Town, thought of as an artists' quarter, but also with a sizeable gay population – shows it has never been widened, and thus retains many original buildings. The shop façades, though, have changed chameleon-like with culture and fashion. One on the left is Prowler, which claims to be the UK's largest gay online store. Next to it is Starbucks, one of six in the Brighton area. Otherwise, the road is an uncomfortable mix of service shops, cafés, pubs, and charity shops; and, at the time of writing, it was considered one of Brighton's most unsafe areas. A 2011 survey by the council found that 95 per cent of people felt unsafe at night. A BBC report quoted a local resident saying that street drinking, derelict buildings, rubbish everywhere, made the place 'feel dangerous'. However, the same report also quoted a councillor saying it was a 'vibrant street with loads of guest houses and tourist attractions nearby'.

KEMP TOWN

WHILE HOVE WAS being enlarged to the west, so Kemp Town developed in the east, originally to a plan by Thomas Read Kemp, hence the name. Kemp was a Member of Parliament until the late 1830s, but ended up fleeing to Paris, to escape creditors, and being buried in Père Lachaise Cemetery. Charles Busby and Amon Henry Wilds were commissioned to design a whole estate of houses. Many of these were constructed by the famous nineteenth-century builder Thomas Cubitt, even after Kemp's flight, thanks to another financer. Sussex Square, just round the corner from this photograph, was completed in the 1850s, and was the largest such housing crescent in the country. Here, though, is Rock Street, a more humble road in the heart of Kemp Town, and the Rock Inn. A barn stood here before 1750, when a coach house was built, and this was converted to a pub in 1787. It would have been somewhat isolated at the time, and, according to the pub's owners, a 40ft well in the basement was almost certainly used by smugglers to store

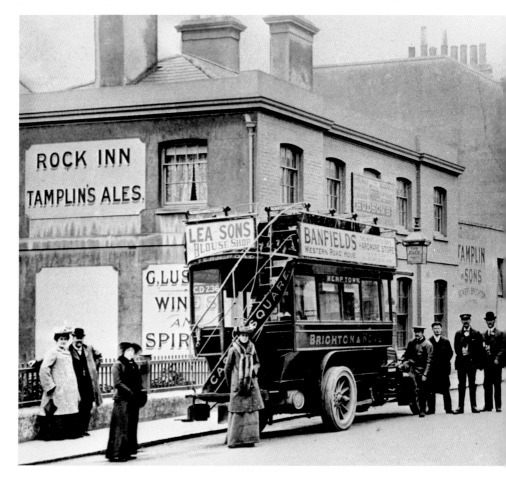

contraband. According to James Gray, the motor bus in the photograph, dated to 1905, was one of the first four to run in Brighton, and the Rock Inn was their eastern terminus.

THE ROCK TODAY is one of 250–300 pubs and drinking establishments in Brighton & Hove, considerably fewer than the 700–800 that existed towards the end of the nineteenth century. The largely residential Rock Street does still have a few retail outlets; during the war, though, it had a full range of shops, including a fishmonger, greengrocer, and butcher. On 14 September 1940, it was hit by a bomb. Ken Brown, a sixteen year old, lived three doors along from the Rock Inn, in his parent's newsagents. Interviewed for the MyBrightonandHove website, he remembered being thrown across the shop by the blast, that there was broken glass everywhere, and that they had to stop children trying to retrieve sweets scattered on the ground. That day was Brighton's worst of the war in terms of casualties – around fifty killed – from seven bombs dropped in Edward Street and the Kemp Town area.

ST GEORGE'S ROAD

THE CHURCH OF St George the Martyr was built in the mid-1820s, at the behest of Thomas Kemp to serve the new estate. St George's Road, which connected Brighton and St James's Street to Kemp Town, was named after the church. Most of the houses along St George's Road were constructed in the decades after the church. This photograph, taken some time in the mid-1910s, shows the start of St George's Road at the junction with Montague Place. Nine hand carts and two horse-drawn carts are ready to deliver milk to the surrounding streets. A cow keeper had been registered at this address since the 1850s (for a while there was a coal merchant too), but it was taken over by the Sussex Dairy Co. in the mid-1880s, which must have built the shop to its own design. By then, there was a red-brick Methodist church opposite, on Bristol Road; and the Kemp Town railway station was a few streets away to the north. For sixty years or so, until 1933, the railway line served passengers from central

Brighton, and thereafter only carried goods until closing permanently in 1971. It had been a costly line to build, needing a viaduct, embankments and a tunnel.

THE INTERESTING SUSSEX Dairy building still stands today, its heritage part-recognised in the name of the corner shop, The Boozy Cow. The Sussex Dairy Co. continued to trade there until the 1920s, after which time it was used for the next forty years or so by Belgravia Dairies. For a short spell in the 1970s, it sold 'economy wallpaper'. The red-brick church opposite (out of view to the left of the photograph) closed for worship in 1989, and now forms part of the public school, Brighton College. Some of the crowd here are dancing to a band playing in front of the church, one of the events in the 2012 Kemp Town Carnival. First launched in 1995, the carnival disappeared for several years, but was revived in 2011. The latest carnival included closed streets with market stalls, a procession – 'Parade of Flowers' – with drummers and dancers, and a mass custard pie throwing. Among the street performers were Vaca Louca, aka the Anarchist Republic of The Mad Cow, 'a colourful collective that whips up circle dances and human tunnels'.

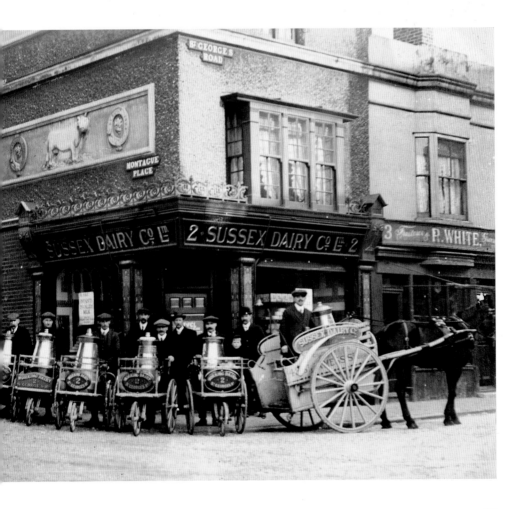

ALBION HILL

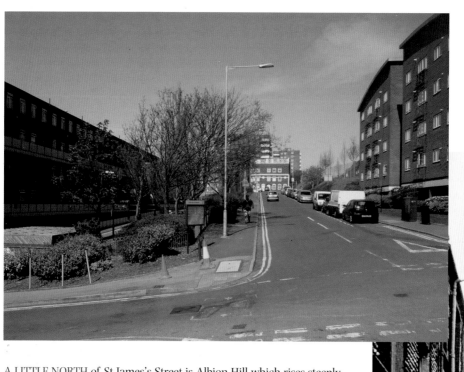

A LITTLE NORTH of St James's Street is Albion Hill which rises steeply
from Brighton's central valley area to the east, and was densely populated
with poor quality housing from the early nineteenth century. Much of
the area was home to fishermen, who cured and smoked their herring
catches in local workshops. Over time, though, it degenerated into slums,
the worst surviving into the 1930s. This 1935 photograph features Nelson
Street, a road that no longer exists, just before a large-scale slum clearance
project took place. In 1988, the community publisher QueenSpark Books
published *Backyard Brighton* which includes a memory by Charlotte
Storrey: 'My mother had 11 or 12 children who were all born in Nelson
Street. Nelson Street was very poor. We had very little furniture, just a table,
2 chairs, an iron bedstead and a mattress. When I was four years old my
mother went to work at the Royal Sussex Hospital rolling bandages for 2/6d
a day. Our neighbours kept an eye on the children when they came home
from school. I can remember the sanitary man visiting the area. He would
walk into the house without knocking, our doors were never locked, and
walk straight up to the bedrooms and pull back the bedclothes to check for
bugs. My mother used to protest that we were still in the beds but he would
say it was the best time to check, when the bed was warm.'

THIS IS NOW John Street. When the slums were cleared, many of the area's residents were re-housed in the council's first housing blocks, Milner Flats (named after Alderman Hugh Milner Black, a council housing enthusiast) and Kingswood Flats (named after a health minister, Sir Kingsley Wood) seen on the left of this photograph. Running between the Milner and Kingswood Flats is a pedestrian path, called Nelson Row, which, unlike Nelson Street, has not changed its name. Behind the camera location of this photograph, John Street continues for another block towards the sea with Brighton's police station on one side (since the 1960s, before which it was located in the Town Hall), and a side extension of the large white American Express building on the other. The latter, sometimes nicknamed 'The Wedding Cake', is the European headquarters of American Express, and was built in the late 1970s.

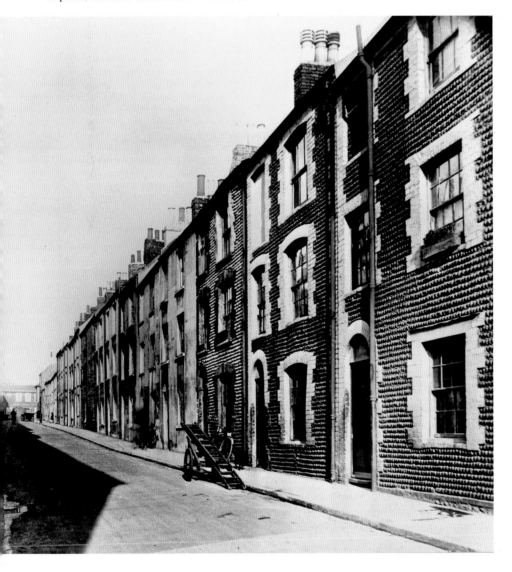

LEWES ROAD

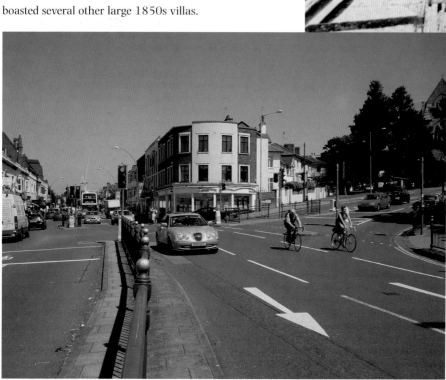

THIS IS 1901, and the trams are coming. The road to the
left is Lewes Road, leading to Moulsecoomb manor, the
village of Falmer and the Sussex county town of Lewes.
Since 1770, it had been maintained by a turnpike trust.
The terrace seen on the left dates from the middle of the
eighteenth century. However, the oldest houses on Lewes
Road – the Percy Almshouses (just out of view to the
right) – were built some fifty or more years earlier in what
was then an isolated spot. Six further almshouses were
later funded by Revd Henry Wagner. The road to the right,
Elm Grove, climbs up to Brighton Racecourse with its
spectacular view towards the sea. So named because it was
planted with elms in 1852, it increased in importance when
a new workhouse was opened, near the racecourse, in the
late 1860s. Housing then developed along the road, and on
the new roads to both sides. The large house shrouded by
trees stood in Wellington Road, just off Elm Grove, which
boasted several other large 1850s villas.

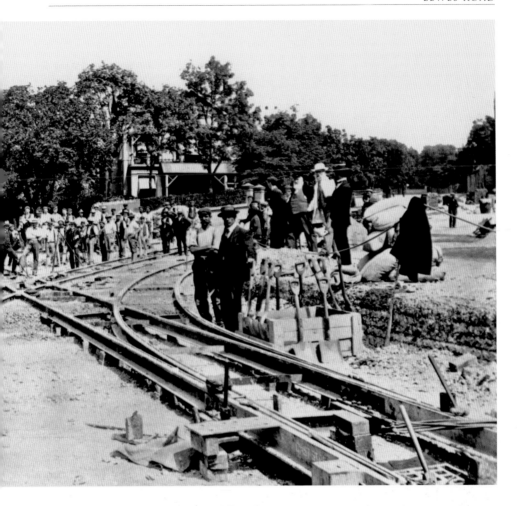

THE TRAM LINES have long since gone, as has the Wellington Road house, but the terrace on the left remains, now housing various local amenity shops. The 200-year-old almshouses are also still there (out of view). The large church just visible on Elm Grove is the Catholic St Joseph's; and much higher up is the hospital. Professional nurses were not introduced to the workhouse and infirmary until the early years of the twentieth century, and they had to wait another three decades or so to have their own living quarters. The buildings were employed as a hospital during the First World War (Kitchener Hospital) but reverted to a poor law institution soon after. Only in 1935 did it become Brighton Municipal Hospital, and then, with the introduction of the National Health Service, Brighton General Hospital. Moulsecoomb, along Lewes Road, is now a Brighton suburb, consisting mostly of a vast housing estate built by the Brighton authorities, starting in the 1920s. And Falmer has come a long way too – Sussex University was established there as a campus university in 1961. Most recently, it has become home to Brighton & Hove Albion football club's brand new stadium, The Amex. Both Moulsecoomb and Falmer house Brighton University buildings. The two universities together serve over 30,000 students.

BRIGHTON MARINA

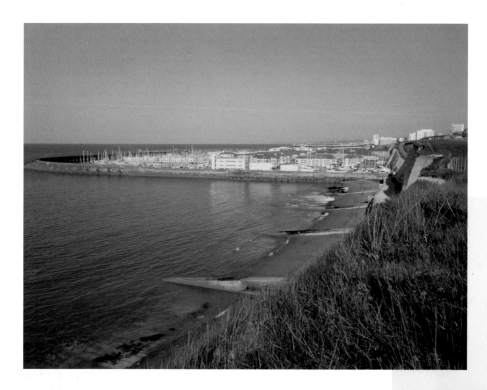

A VIEW LOOKING west towards Brighton, from halfway along the
coast to Rottingdean, shows white cliffs – laid down in a warm ocean
over 85 million years ago – and a newly built path at their base.
Also visible in the distance is the built-up area of Kemp Town and,
below it, the area known as Black Rock, at the east end of Brighton's
seafront. The Undercliff Walk, as the path is called, was formally
opened in 1933, the year after this photograph was taken, and
followed the incorporation of Rottingdean village into the town of
Brighton. A few years after that, a seawater lido was opened at Black
Rock and proved very popular for many years.

LOCAL GARAGE OWNER Henry Cohen first dreamed up the idea of
a marina in 1963. His original plan of a site nearer central Brighton
met considerable opposition, and was moved east of Black Rock before
planning permission was finally granted. Construction took most of the
1970s, the huge east and west breakwaters requiring seventy-four and
thirty-six caissons respectively, with each caisson weighing 600 tonnes.
Although formally opened by the Queen in 1979, development was far

from complete, and when the backers ran out of money in the mid-1980s, the complex was bought by the Brent Walker group (which had developed the Brent Cross shopping centre in London). Under the new ownership, the inner area was built on reclaimed land and saw the introduction of a supermarket, restaurants, a cinema centre, and houses and flats – a marine village. Brent Walker went into administration in the early 1990s, and since then development has been somewhat piecemeal. In 1998, Parkridge Developments bought the land and developed the waterfront area with shops, bars and a hotel. In 2007, the commercial estate was sold to X-Leisure for £64 million. Several major plans – for redeveloping the west side, for a skyscraper and for pedestrian bridges – were refused planning permission on appeal in 2010. The Black Rock lido was closed and demolished in the late 1970s. Since then the site has been overshadowed by the marina and its access roads. Nevertheless, it is occasionally used for one-off entertainments or festival events, and may – if finance can be found – host a new multi-sports arena.

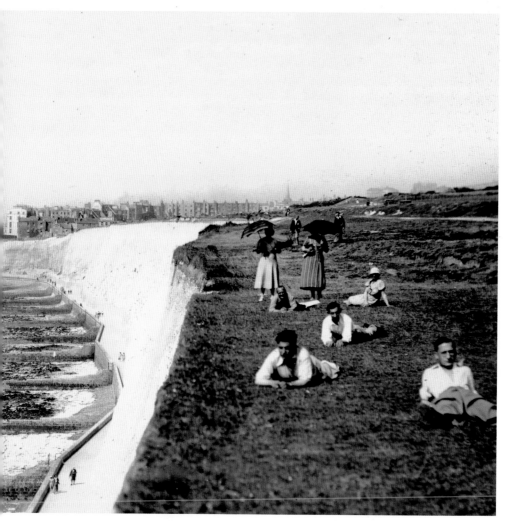

WEST BLATCHINGTON WINDMILL

WEST BLATCHINGTON WINDMILL was built around 1820 on a tall flint and brick tower to grind corn; and not long after, the famous English painter John Constable made a sketch of it. This is a 'Smock' mill, so-called due to its resemblance to an old miller's garment; but this one, unusually, was built with only six sides (not eight). At the time of this photograph, around 1890, West Blatchington was a remote hamlet, north of Hove, a mile or so from the nearest houses. The windmill was still operating, though it would cease to do so in 1897. Records show that more than twenty windmills existed in

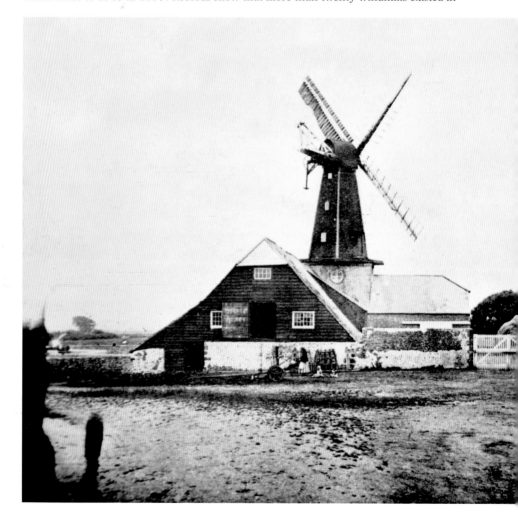

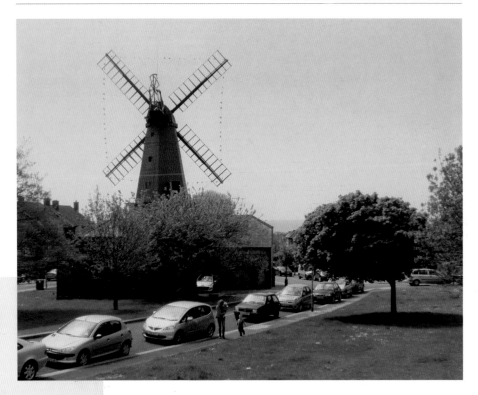

Brighton itself – and many more in nearby villages and hamlets such as West Blatchington – up to and including the nineteenth century, although most near the centre had been demolished or stopped working by the early 1800s.

FOLLOWING INTENSIVE ROAD and house construction during the inter-war period, West Blatchington became a residential suburb. Only the windmill and a nearby church remain of the old hamlet, and the mill itself stands somewhat isolated on a central island, surrounded by roads and housing estates. However, it is a much-loved heritage building, restored and opened to the public in 1979; and it has been well looked after since by Friends of West Blatchington Windmill. Brighton & Hove City Council, which owns the structure, carried out a major restoration of the mill's exterior in 1999. It is open to the public on Sunday afternoons, and visitors are offered the hands-on experience of grinding with a stone quern, as well as a small industrial archaeology museum. There are no windmills left in central Brighton today, but Patcham, which like West Blatchington is a city suburb, has one. Slightly further out are the Jack and Jill windmills at Clayton, and the Rottingdean windmill on the cliffs east of the marina.

If you enjoyed this book, you may also be interested in …

Brighton in Diaries
PAUL K LYONS

This fascinating collection of extracts contains diarists famous and ordinary, young and old, serious and cynical, but with Brighton always setting the scene. Many legendary writers and also less well-known characters can be found within. There are also several diarists whose writing has never appeared in print before – Olive Stammer, for example, who kept a diary during the Second World War. By turn insightful, hilarious and profound, *Brighton in Diaries* will delight residents and visitors alike.

978 0 7524 6222 6

Brighton & Hove A Pocket Miscellany
DAVID J. BOYNE

Did you know? Brighton is home to the world's oldest aquarium and the UK's oldest electric railway or that there are over 400 pubs in Brighton and Hove. This engaging little book is packed full of insider knowledge, facts, figures and the secrets of the vibrant city of Brighton & Hove: diversity, culture, the arts, history, comedy, festival and creativity in bucket-and-spade loads.

978 0 7524 6798 6

Life in Brighton
CLIFFORD MUSGRAVE

Brilliantly researched and written, this is the definitive history of the city of Brighton. Divided into five sections – Fishermen and Farmers, Princes and Palaces, Late Georgian, Victorian Marvels and Mysteries, Battle Scene and Transformation – it shows how Brighton grew from a small fishing village. It was first published in 1970. This new edition includes a double introduction by the late Clifford Musgrave's son, Stephen Musgrave, and author of Georgian Brighton, Sue Berry. Two letters from Graham Greene to the author are also featured.

978 0 7524 6047 5

A Century of Brighton & Hove
DAVID ARSCOTT

This fascinating selection of photographs illustrates the extraordinary transformation that has taken place in Brighton & Hove during the twentieth century. Drawing on detailed local knowledge of the community, and illustrated with a wealth of black-and-white photographs, this book recalls what Brighton & Hove has lost in terms of buildings, traditions and ways of life. It also acknowledges the regeneration that has taken place and celebrates the character and energy of local people as they move through the first years of this new century.

978 0 7509 4907 1

Visit our website and discover thousands of other History Press books.

www.thehistorypress.co.uk